Botanical
Flower Mandalas
coloring book
Volume 1

Illustrated by
Pamela Duarte

Botanical Flower Mandalas Coloring Book, Volume 1
©2019 Pamela Duarte

All rights reserved. No part of this book may be reproduced or transmitted by any form or by any means, electronic or mechanical, including photocopy, recording, or any information storage or retrieval system, without prior written consent from the author.

I have created coloring books for other clients in my career as a professional illustrator but for a long time have wanted to illustrate a book in which I could create the subject matter on my own. I love flowers and the natural world and so chose that as the inspiration for this book. If you love flowers too, please collaborate with me!

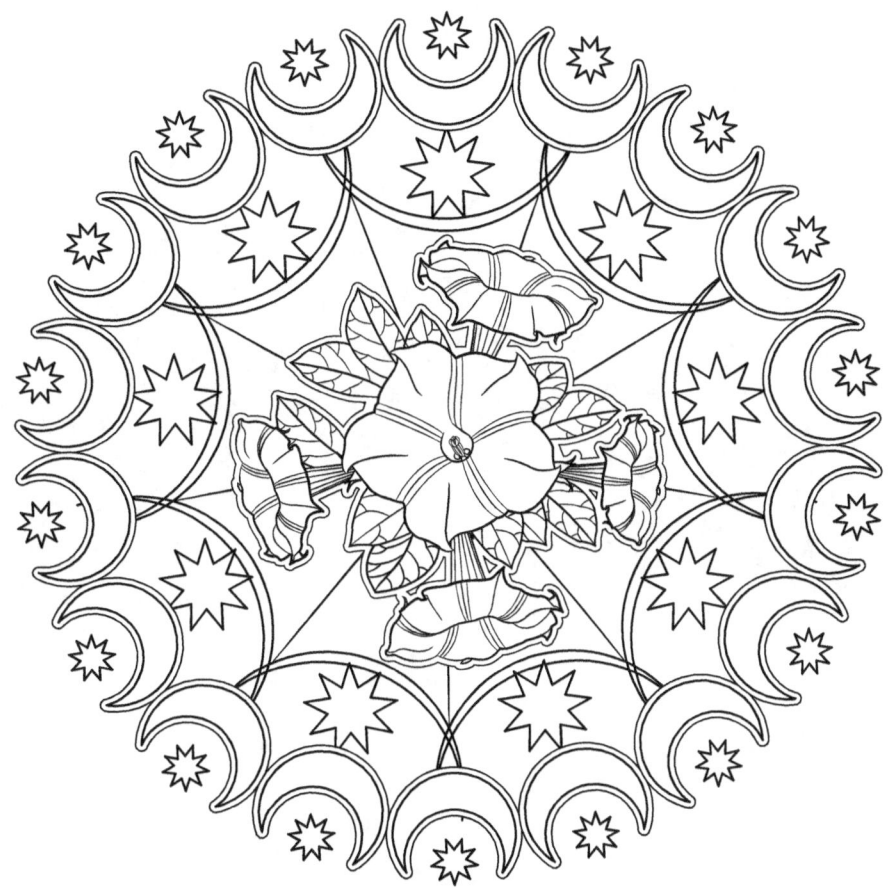

This book is dedicated to 3 strong women:

My Mother who has always been supportive of my goals,
My Grandmother who taught me to appreciate beauty,
and to
Carolee Bingham who loved to color mandalas
& who inspired this book.

This is a new addition of "Flower Mandalas, Vol. 1" published in 2015. The art has been resized and, in some cases, revised and each design has been printed twice.

The pages of this book are suitable for colored pencils, markers, and a variety of other media. They are only printed on one side and to help prevent bleed through, please place a blank sheet of paper between the pages when coloring.

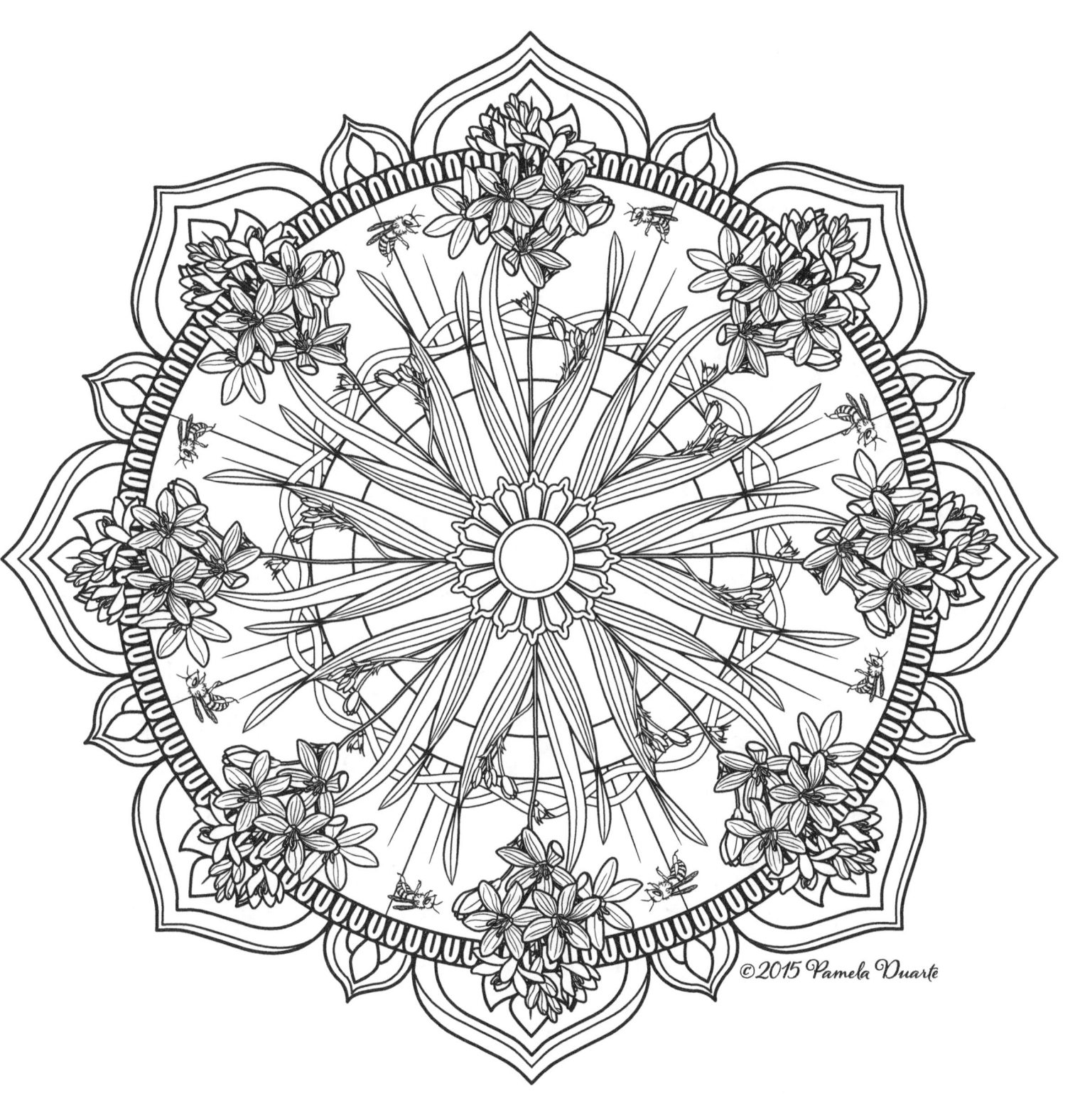

African Corn Lily
Ixia Longituba

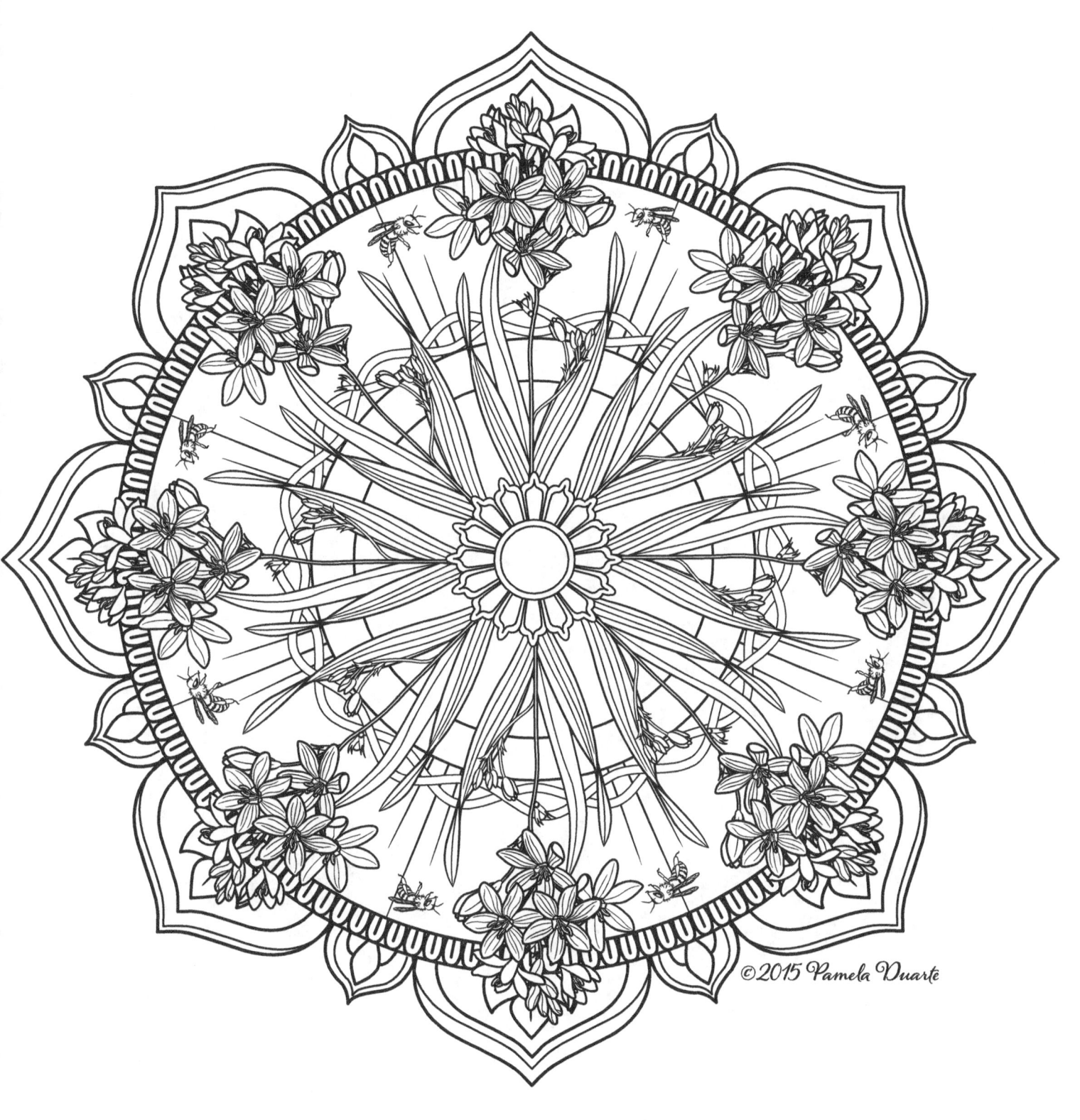

African Corn Lily
Ixia Longituba

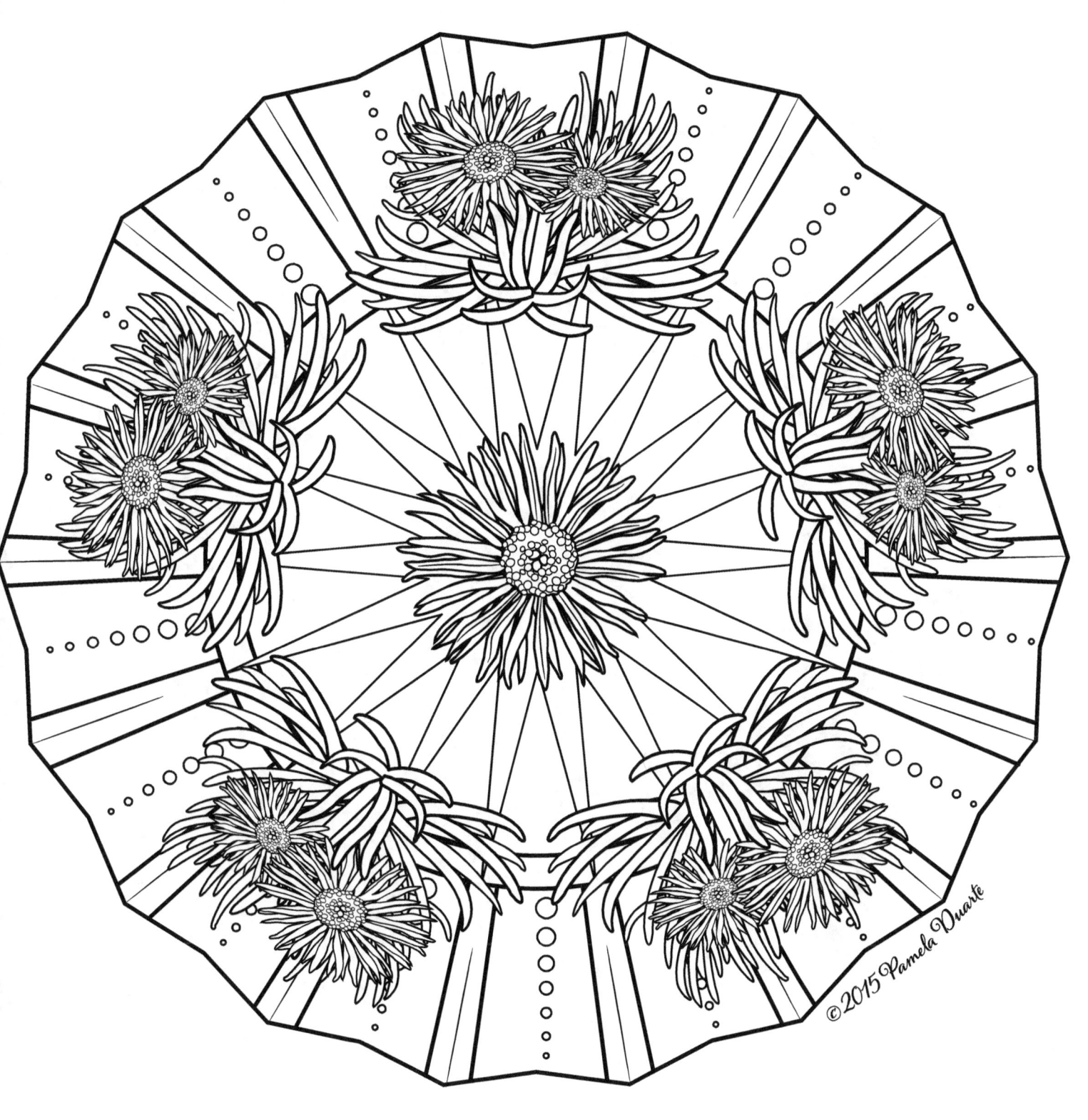

African Ice Plant
Cephalopyllum Pillansii

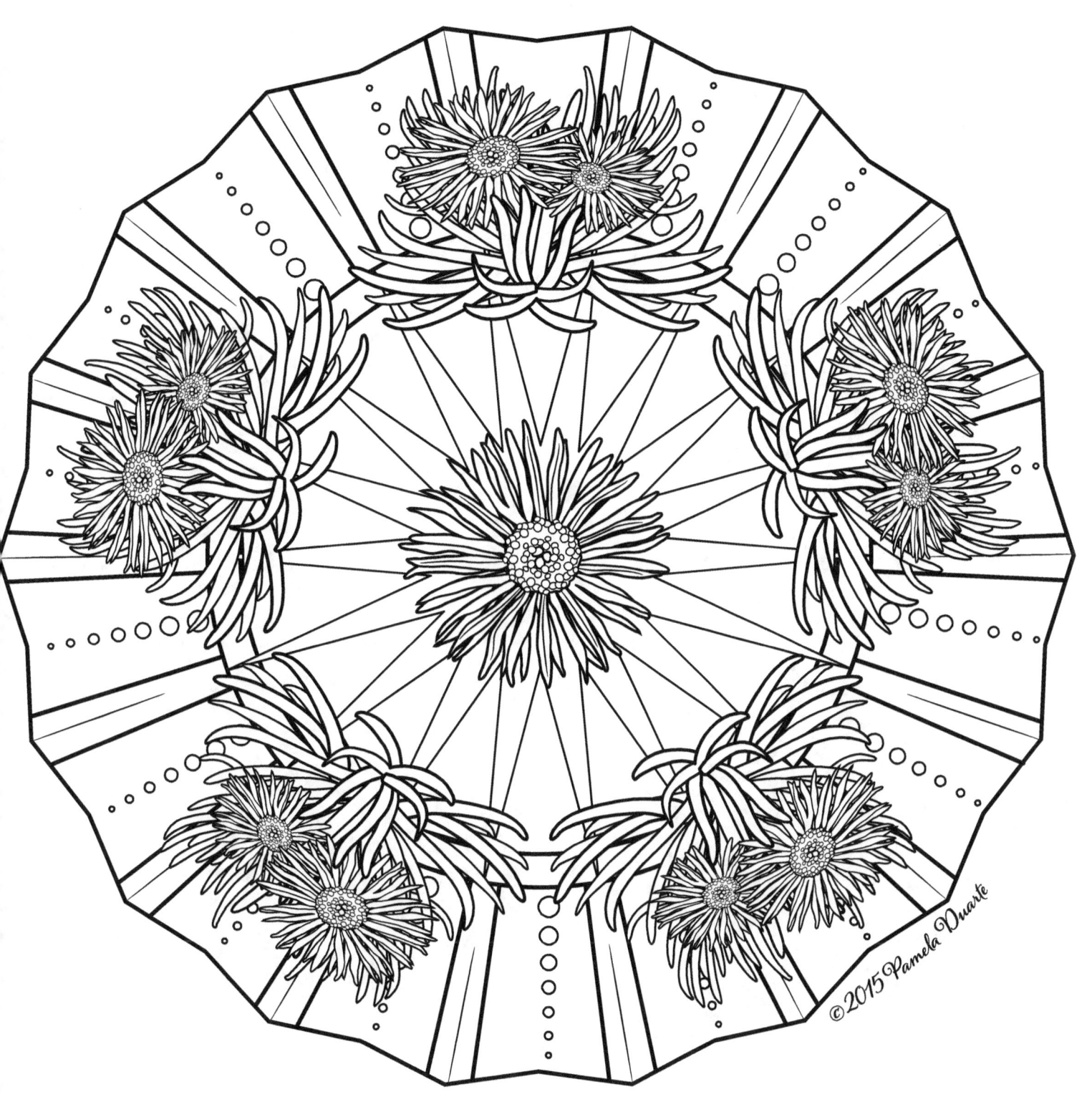

African Ice Plant
Cephalopyllum Pillansii

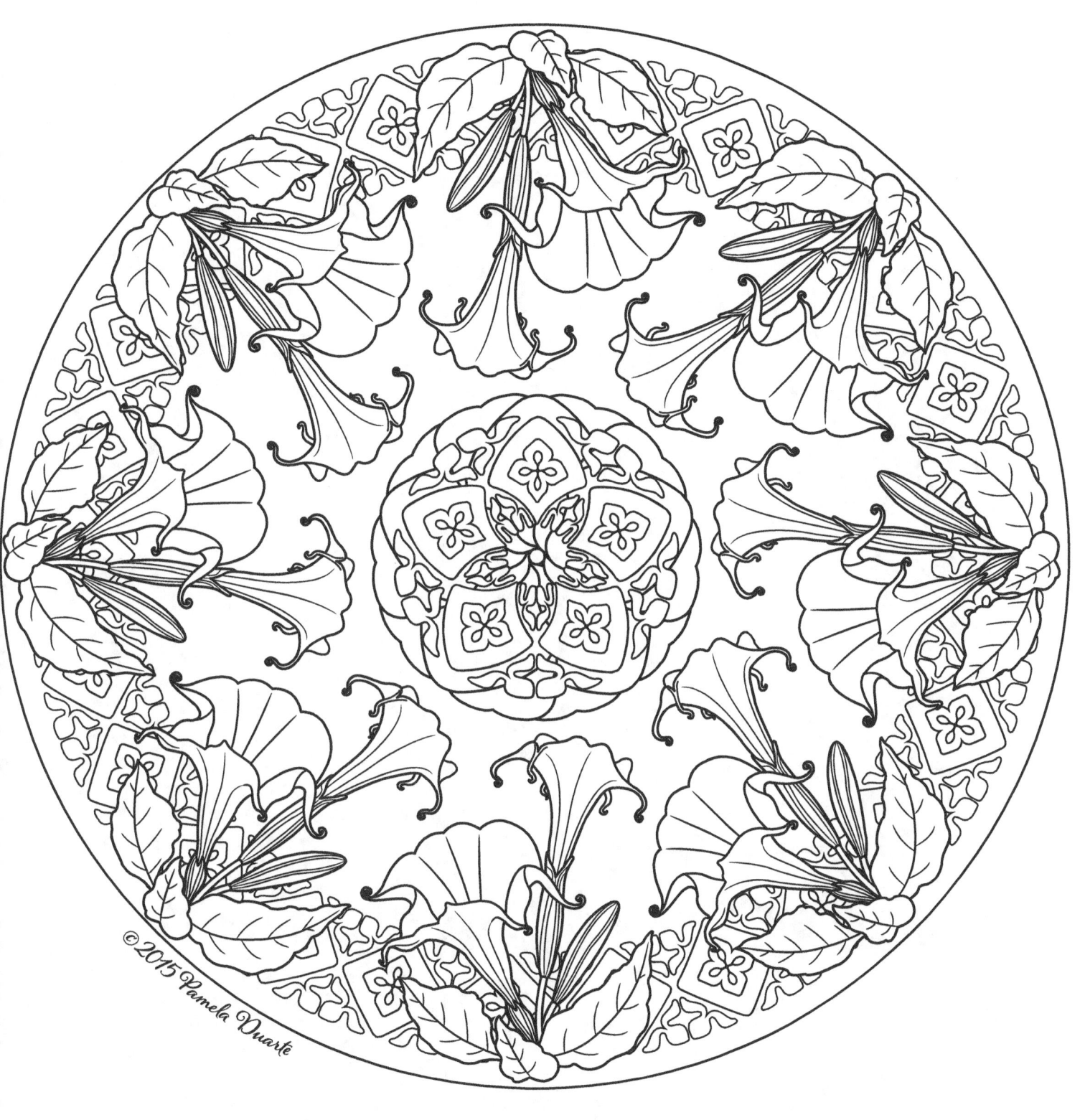

Angel's Trumpet
Brugmansia

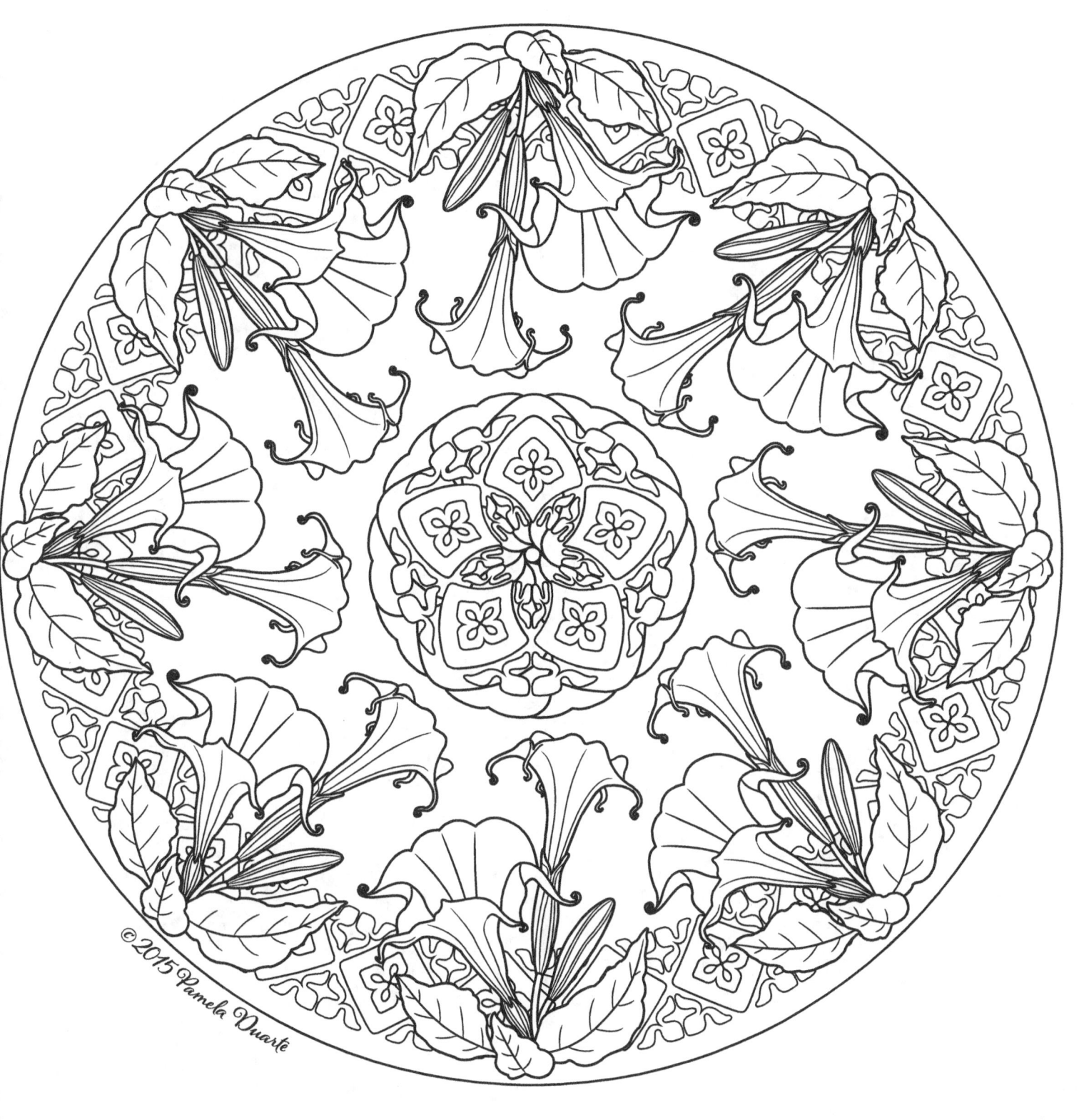

Angel's Trumpet

Brugmansia

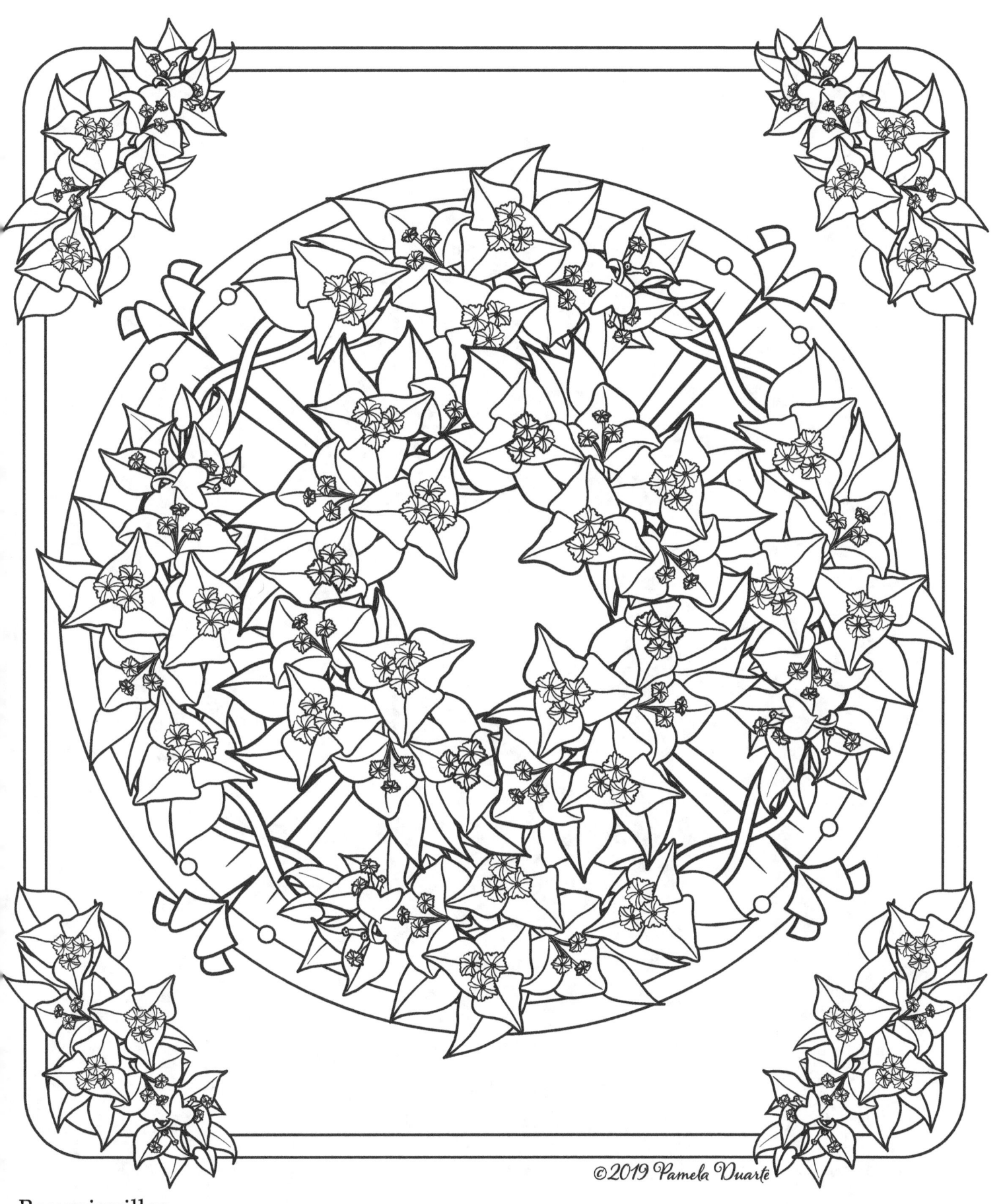

Bougainvillea
Bougainvillea glabra

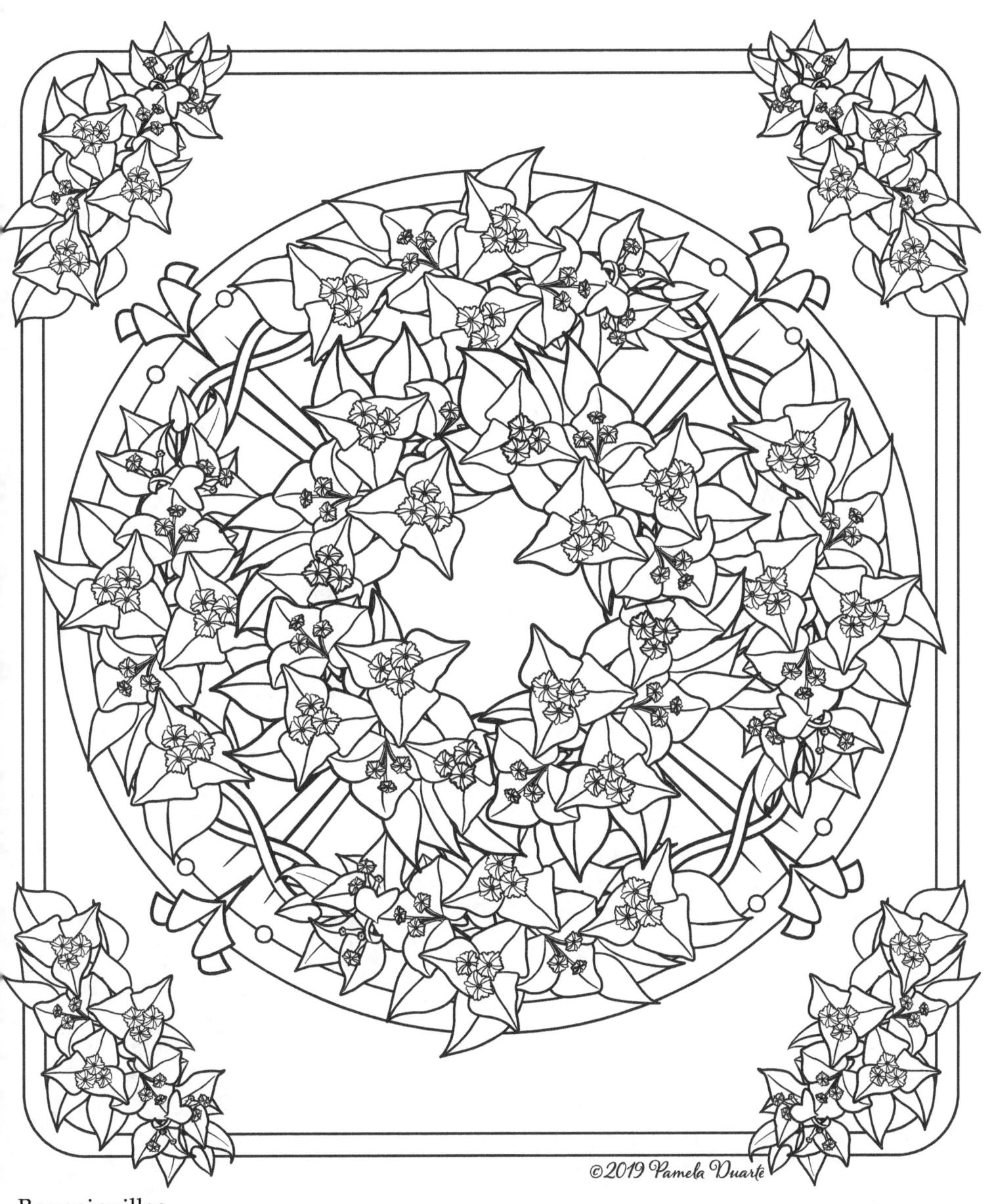

Bougainvillea
Bougainvillea glabra

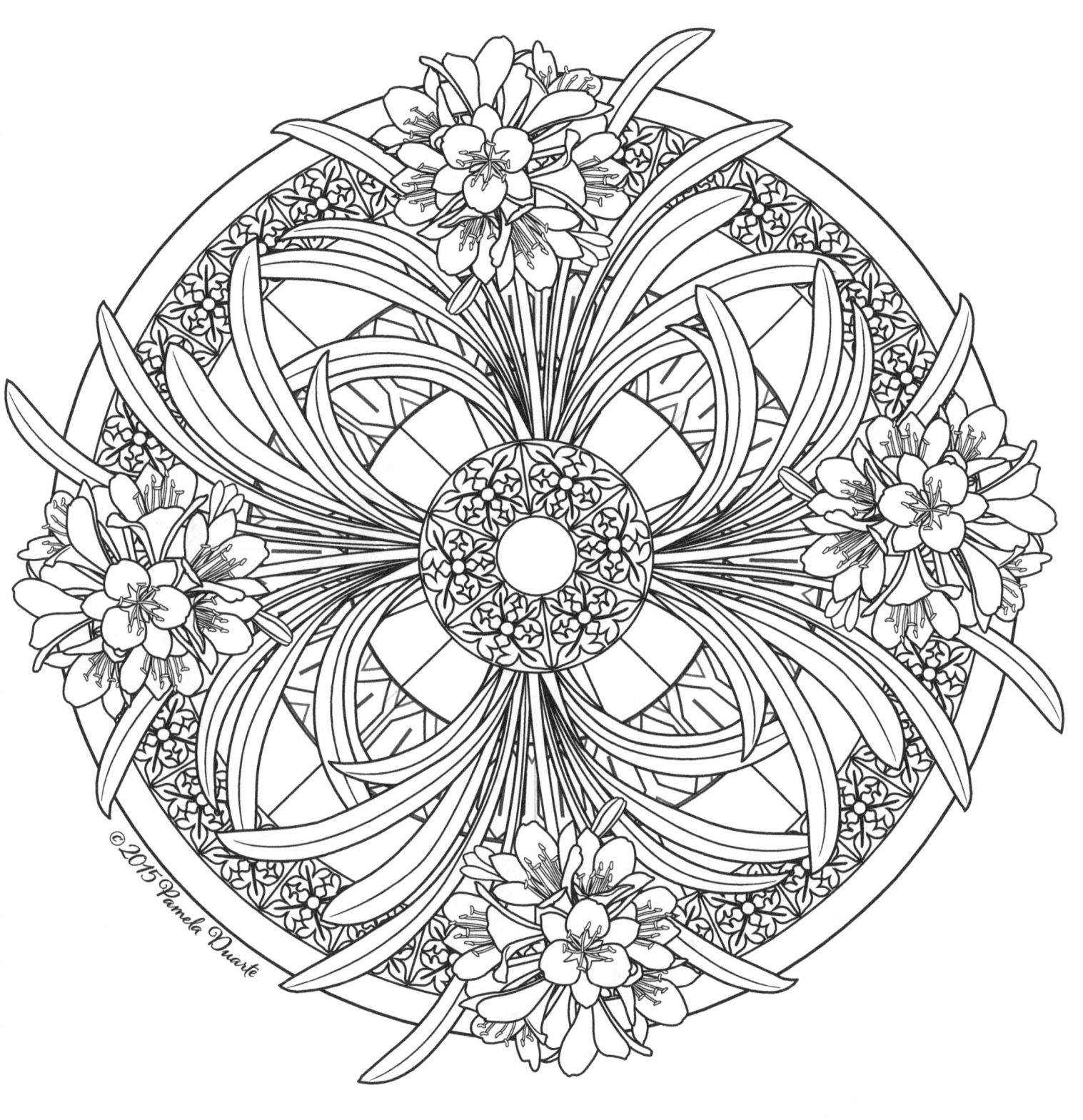

Clivia
Amaryllidaceae

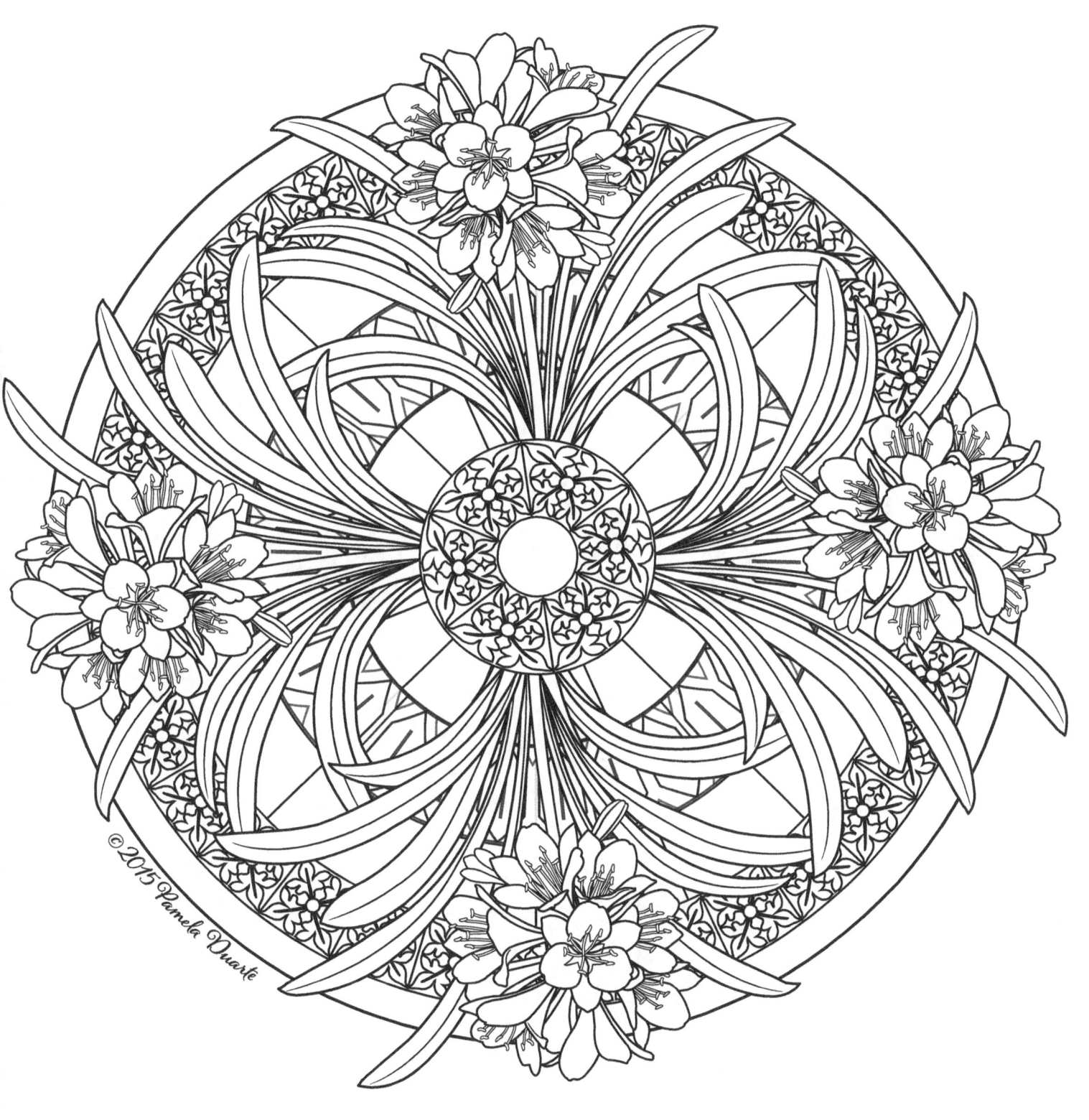

Clivia
Amaryllidaceae

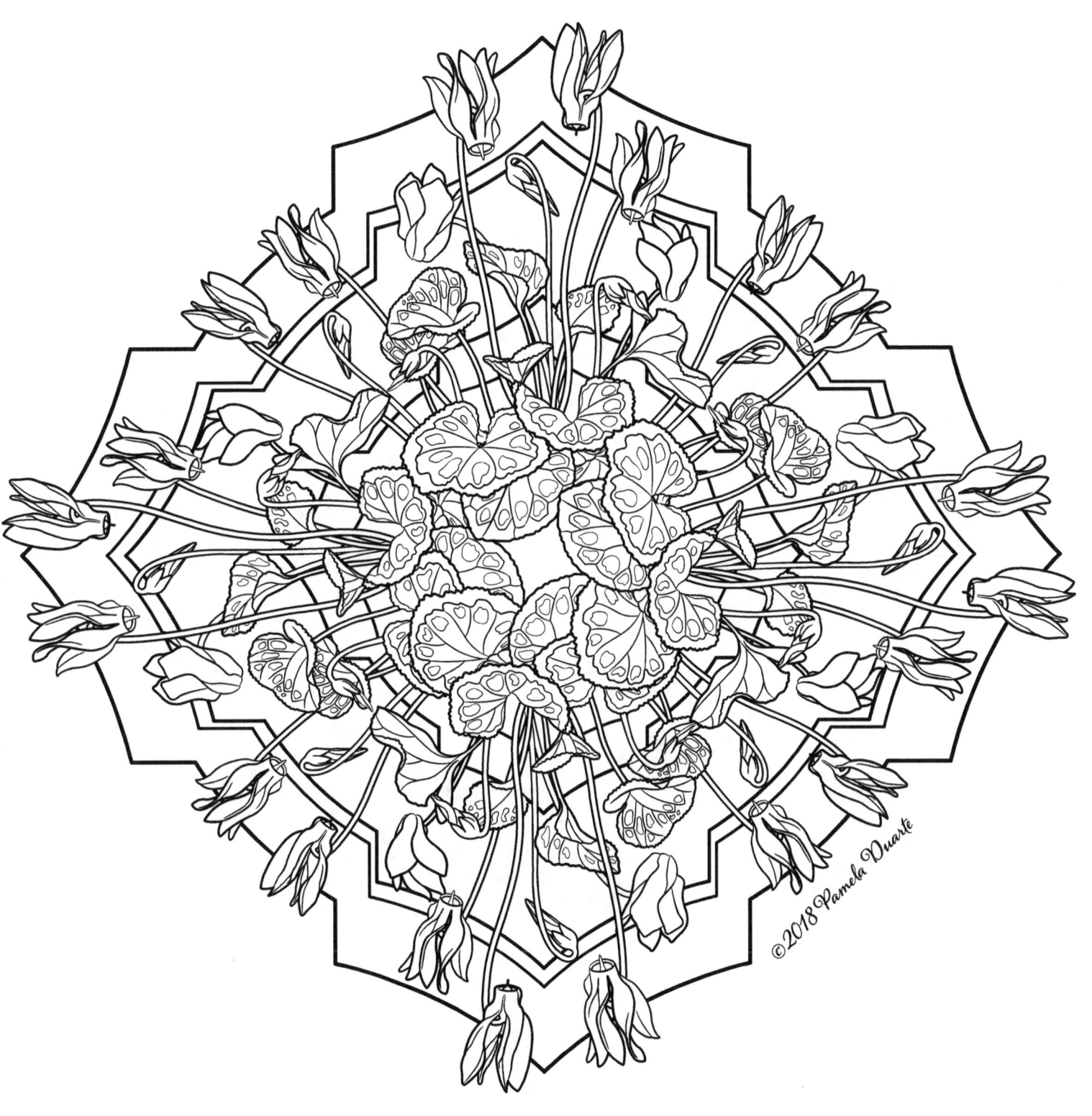

Cyclamen
Primulaceae

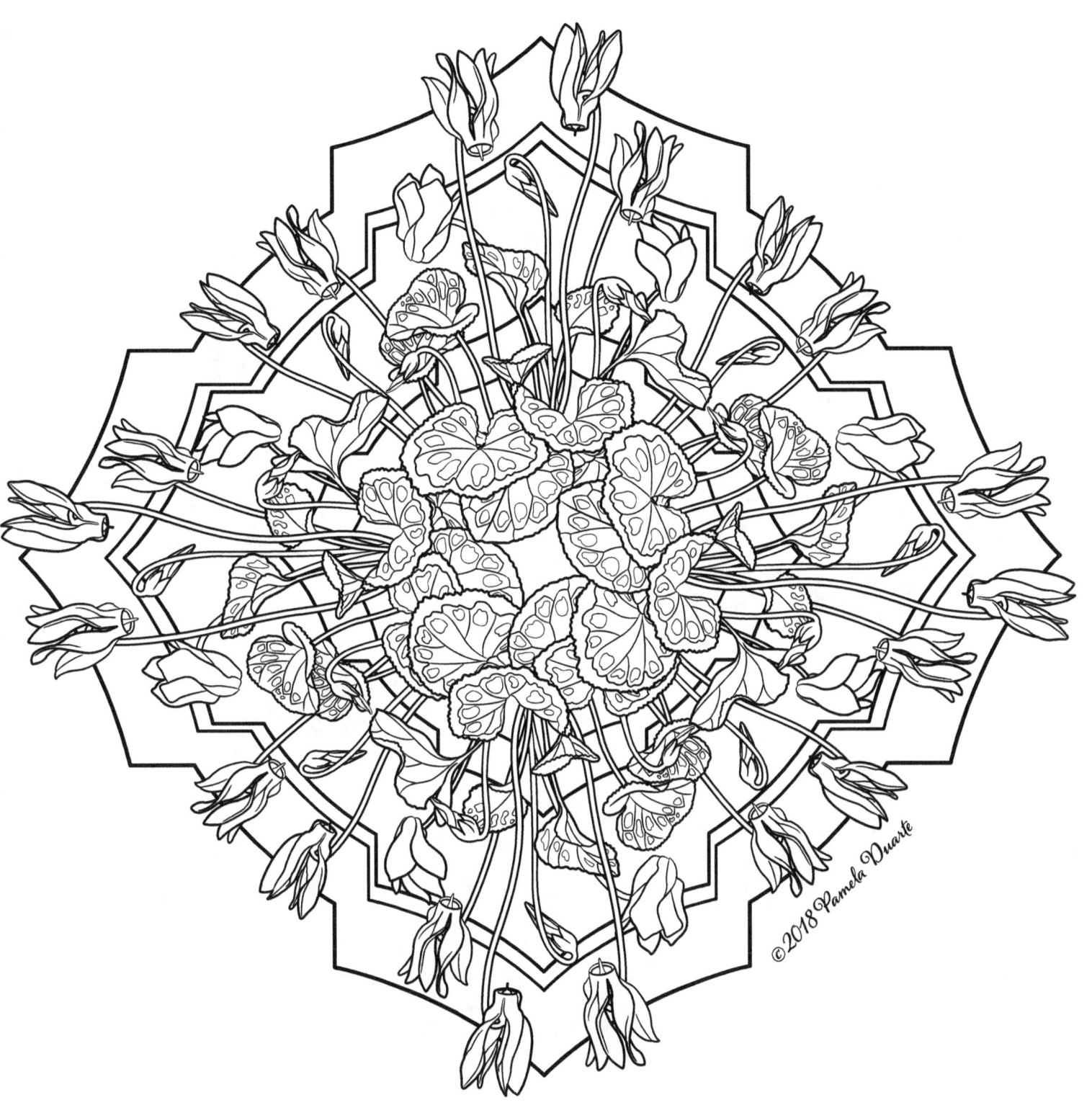

Cyclamen
Primulaceae

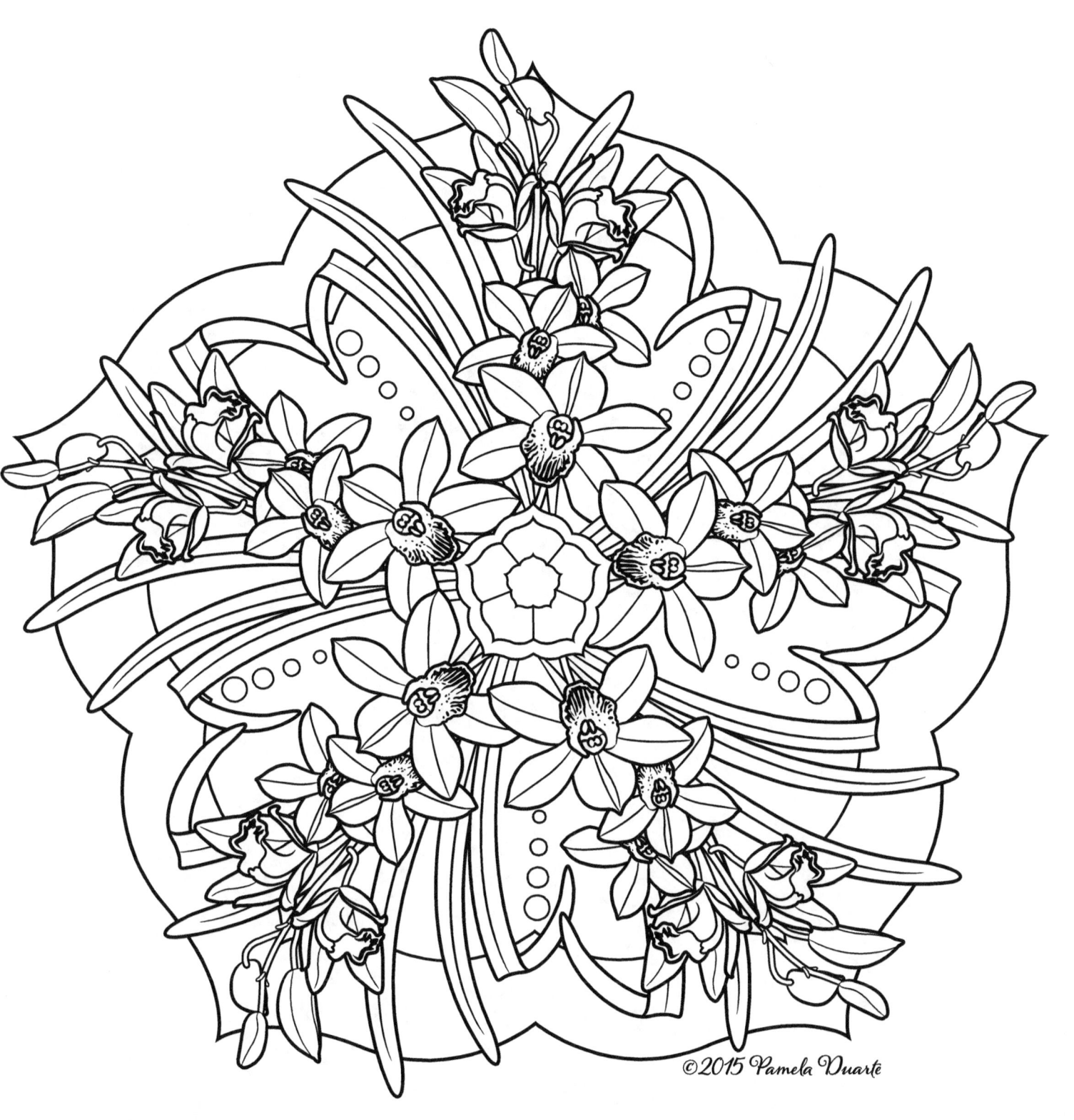

Cymbidium Orchid
Orchidaceae

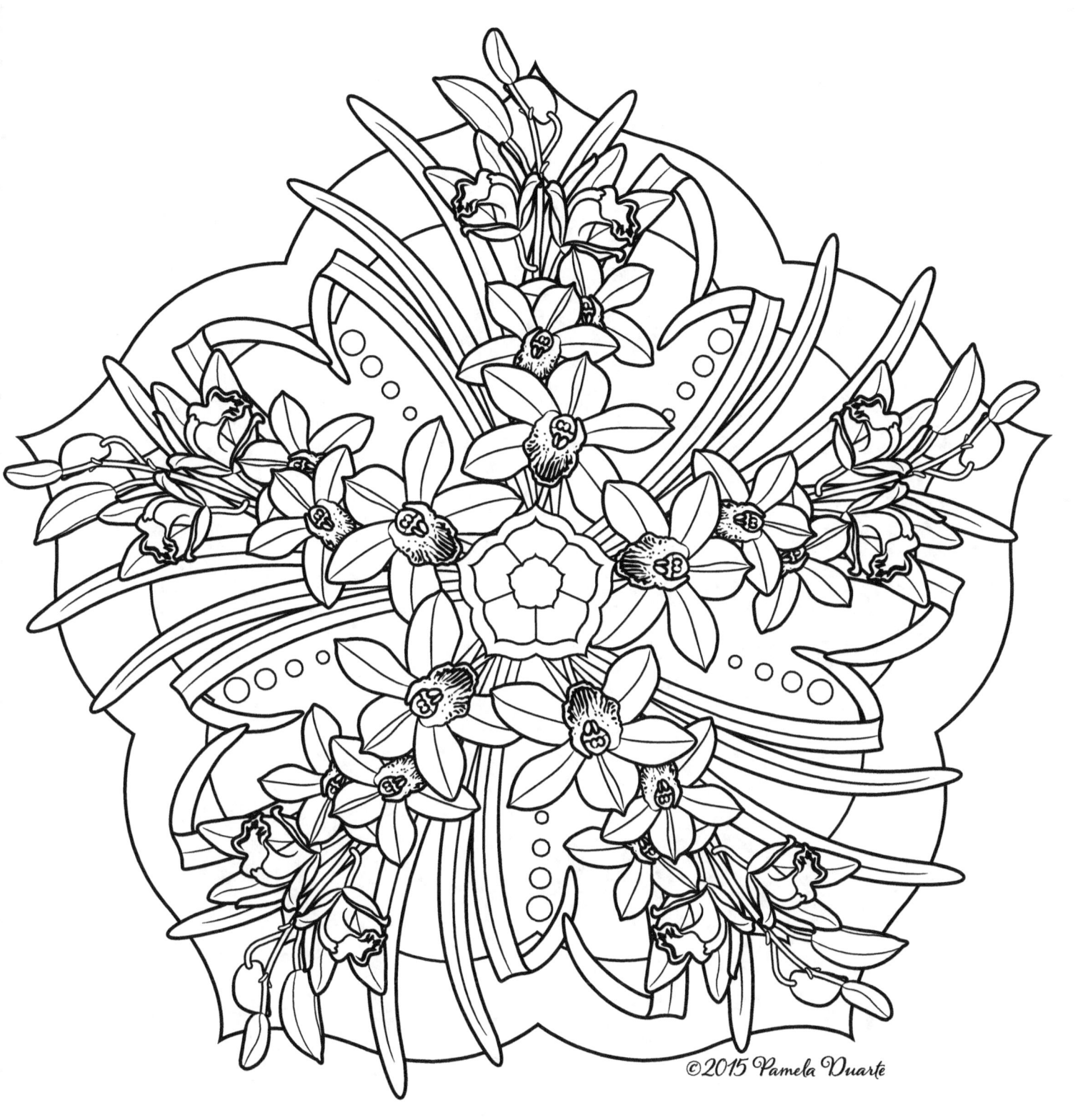

Cymbidium Orchid
Orchidaceae

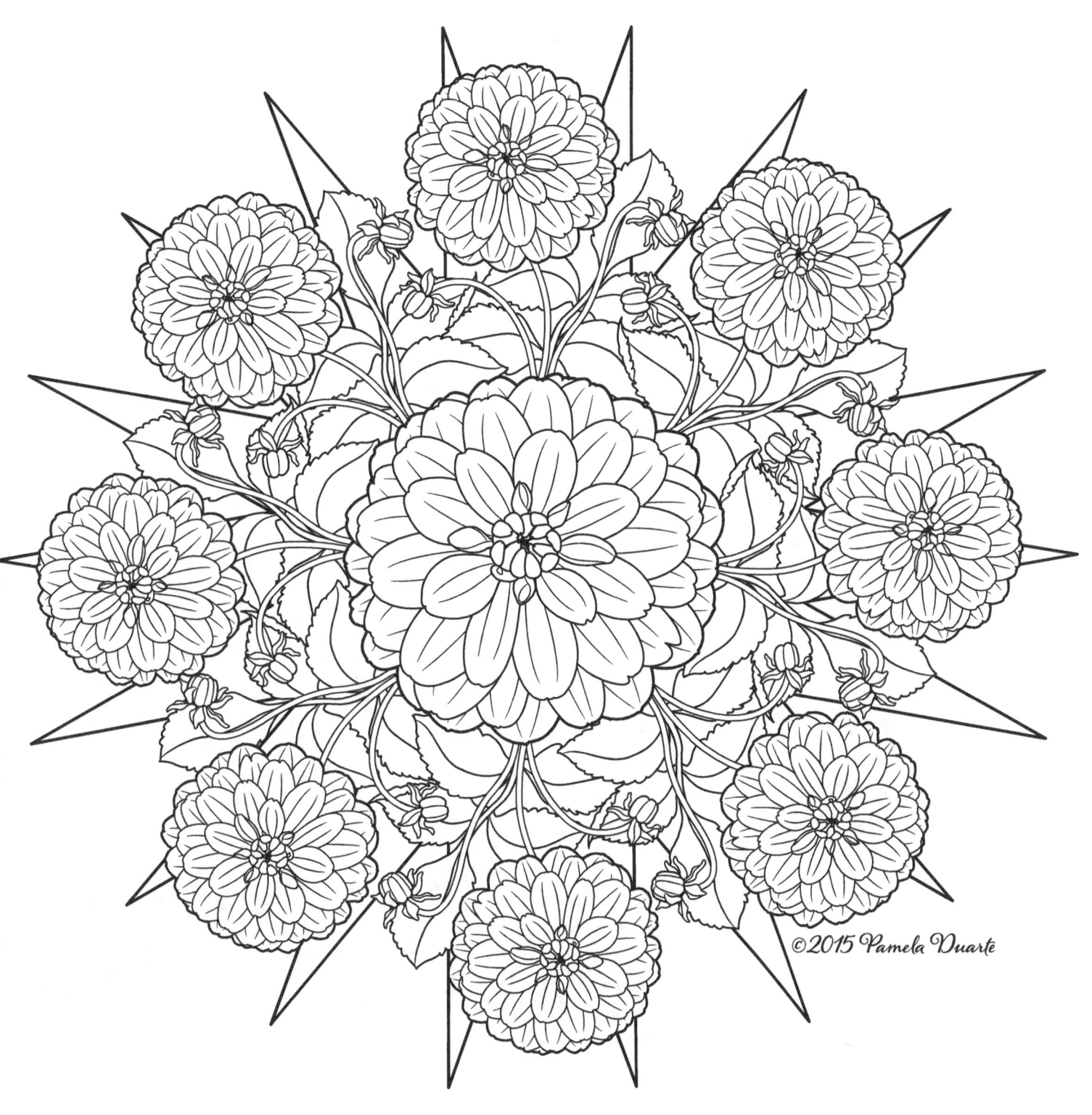

Dahlia
Asteraceae

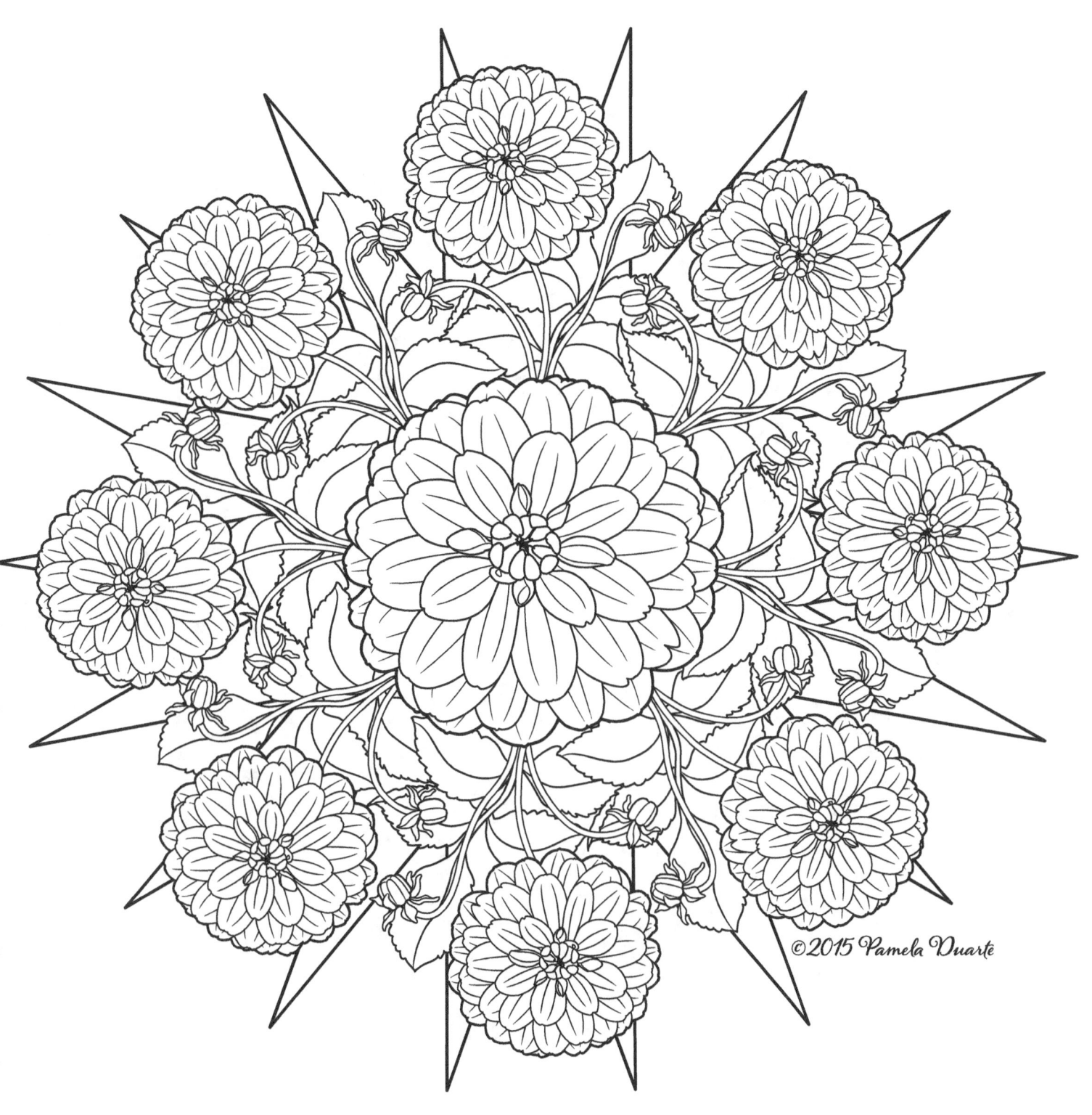

Dahlia
Asteraceae

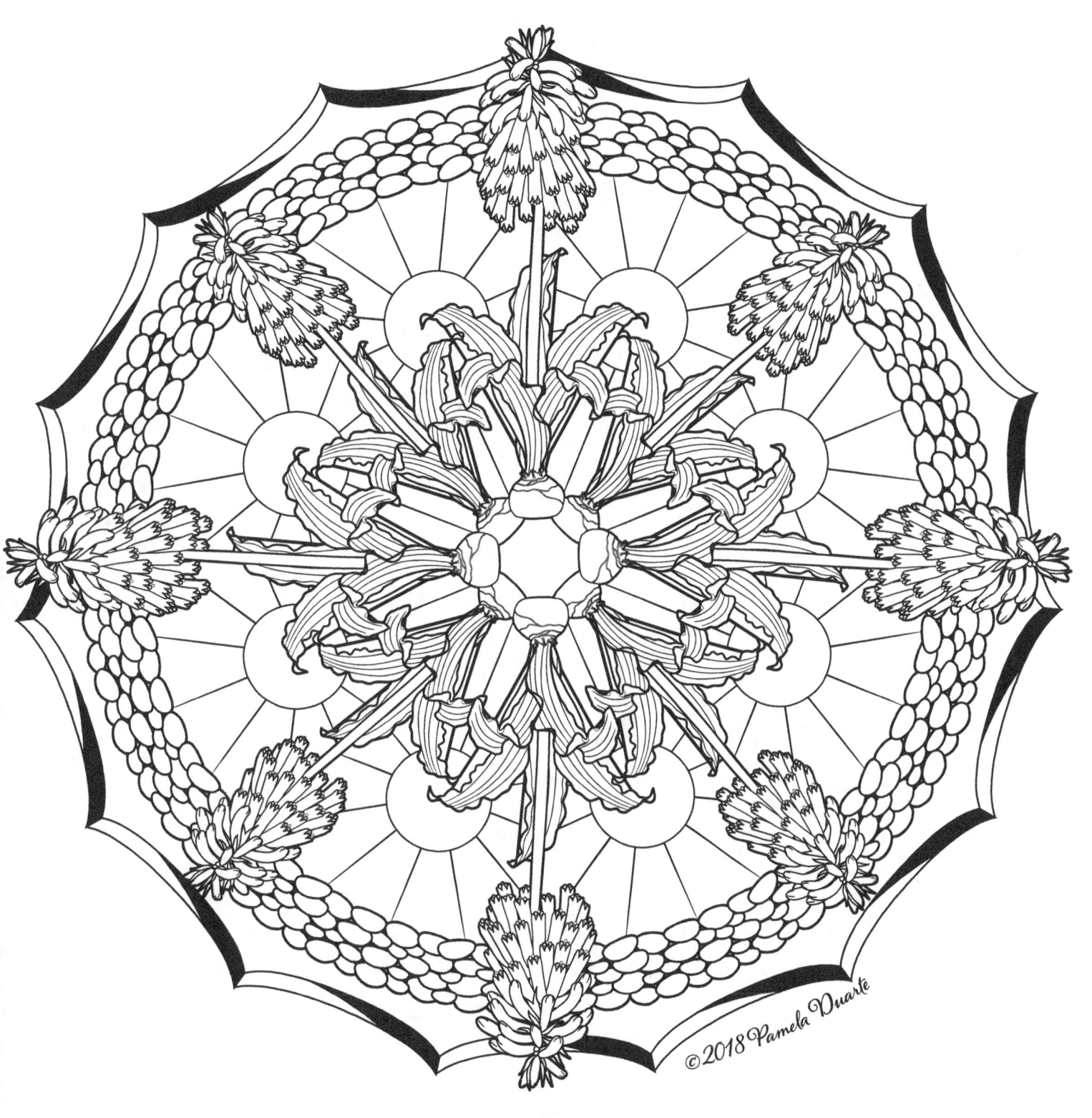

Forest Lily
Veltheimia Bracteata

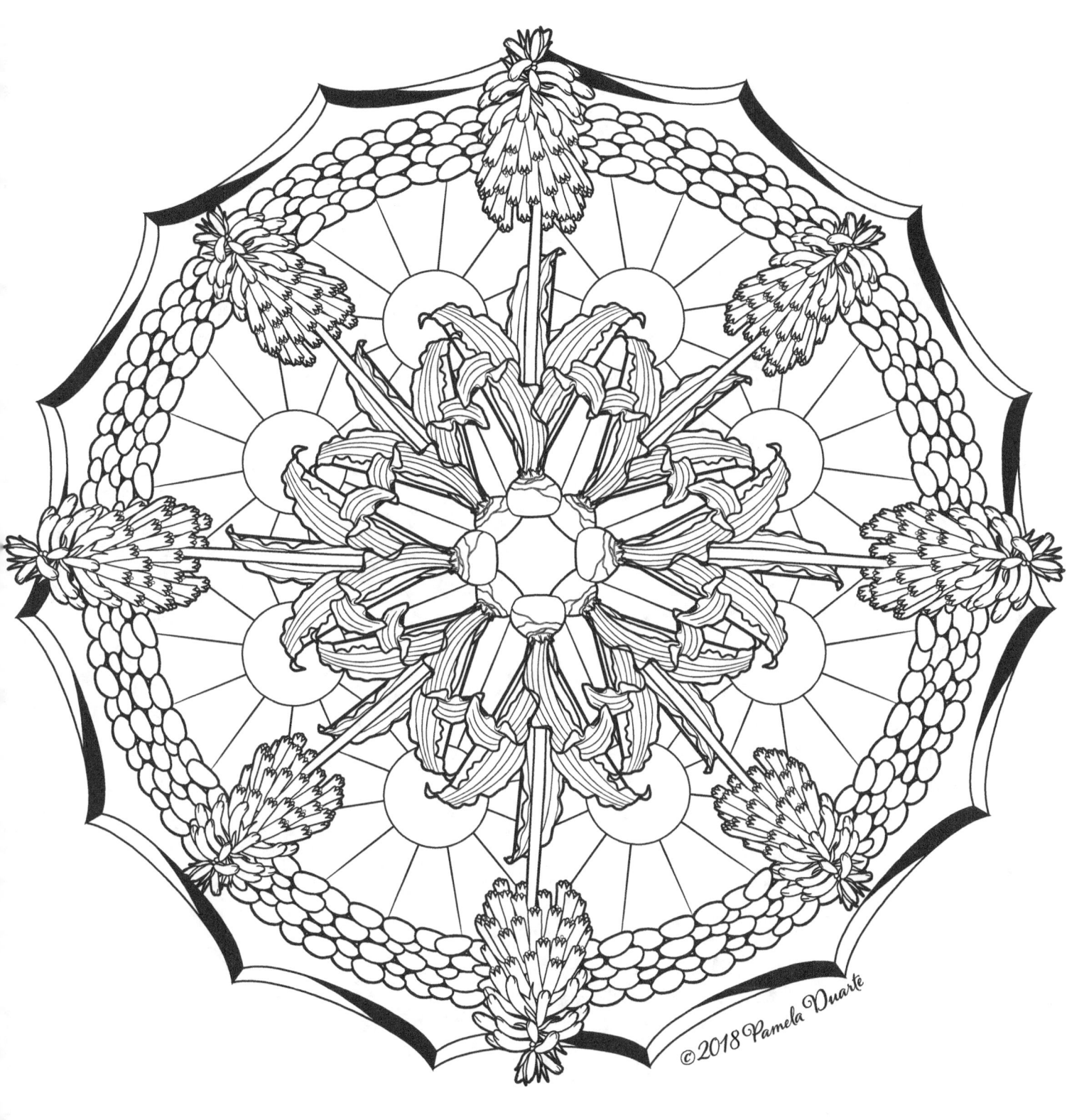

Forest Lily
Veltheimia Bracteata

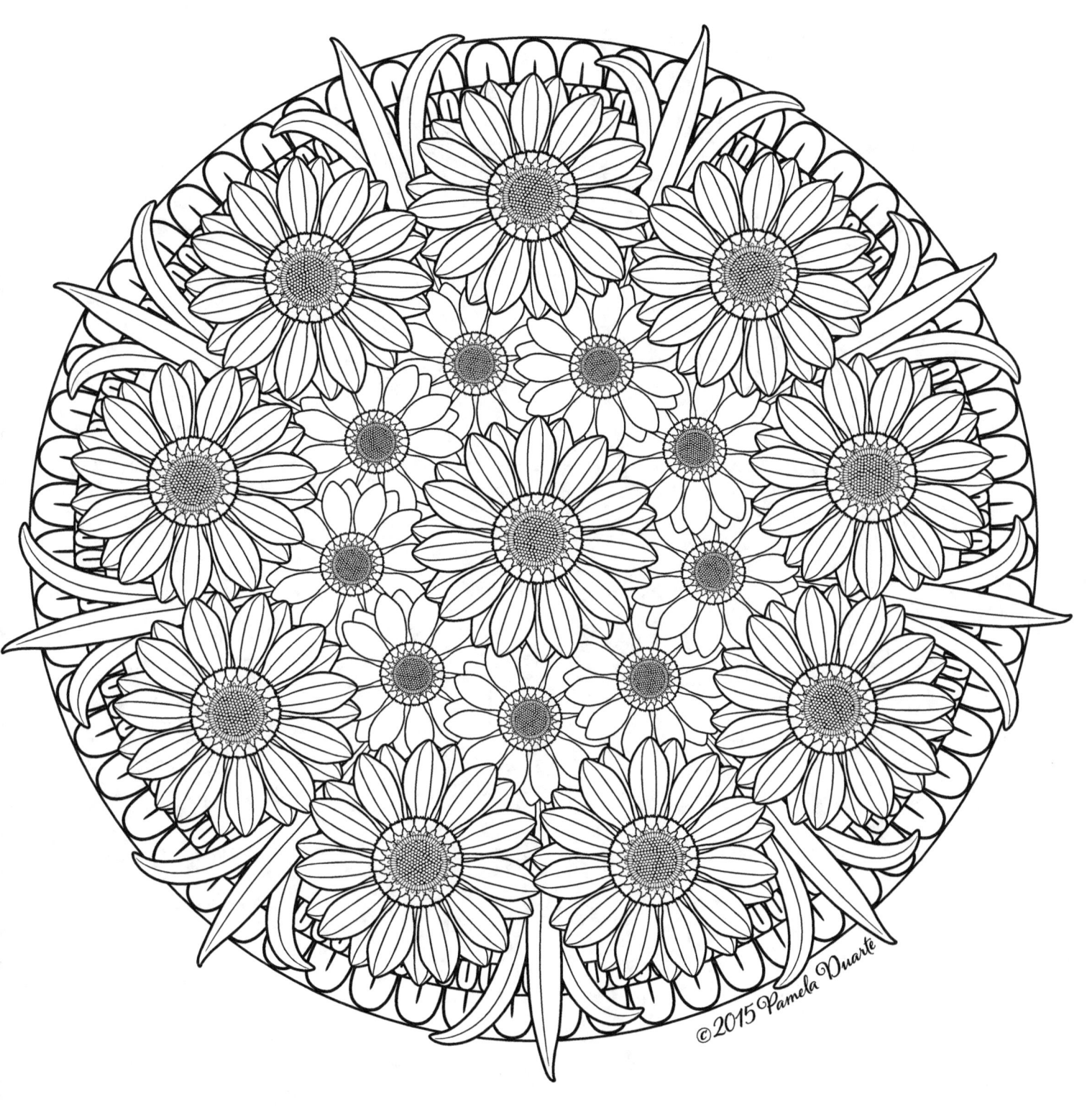

Gazania
Gazania Splendens

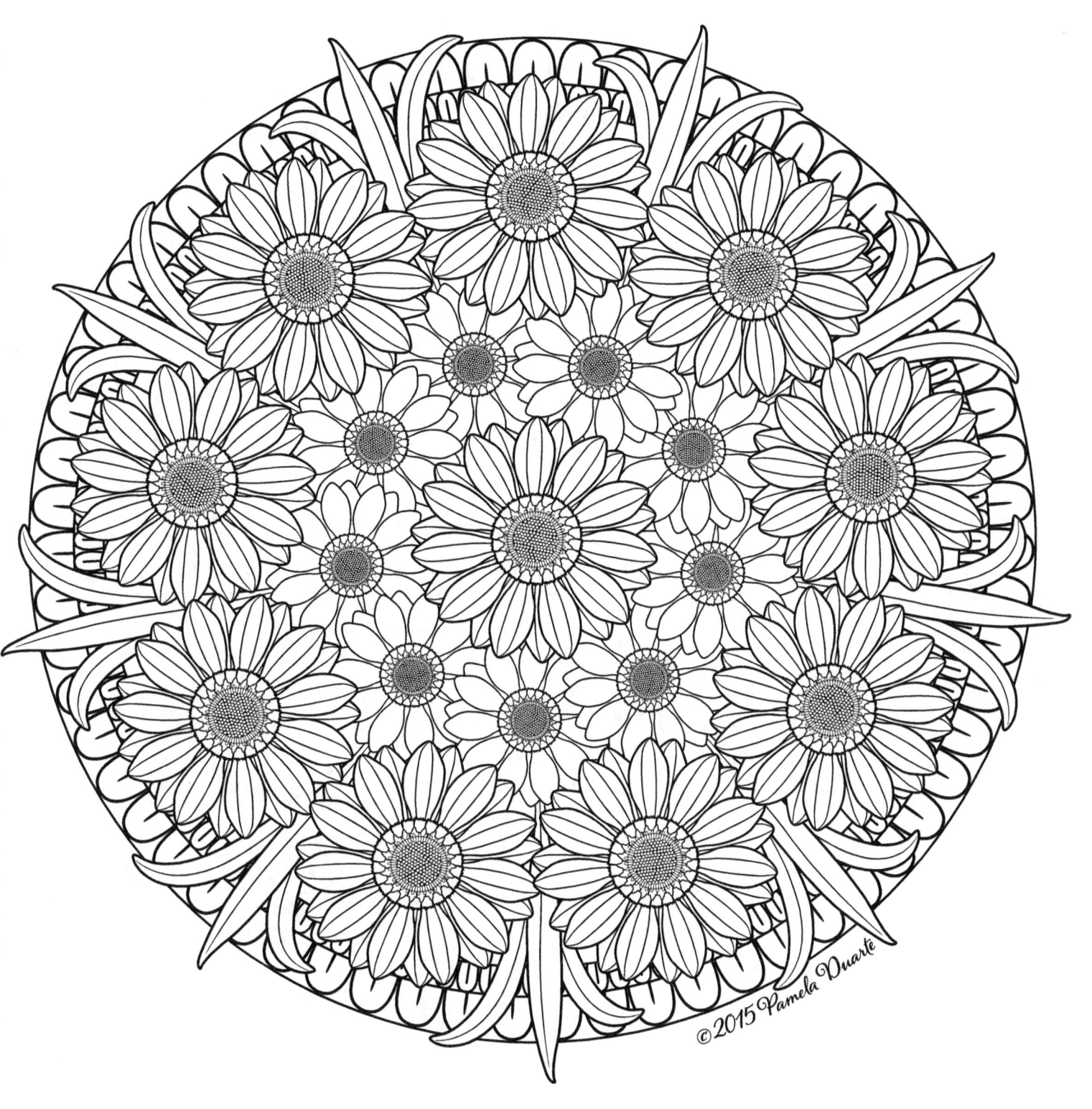

Gazania
Gazania Splendens

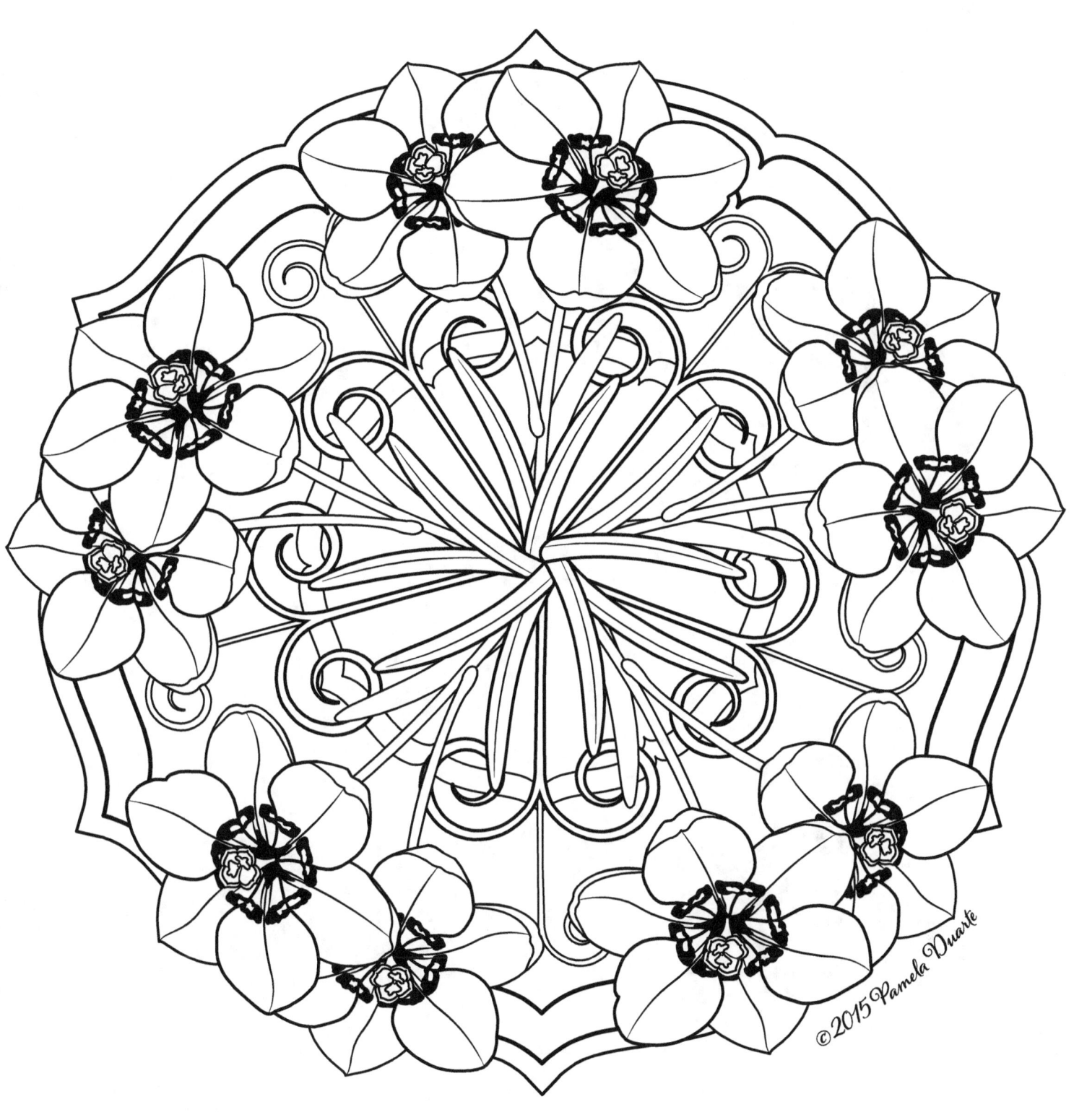

Harlequin Flower
Spraxix Elegans

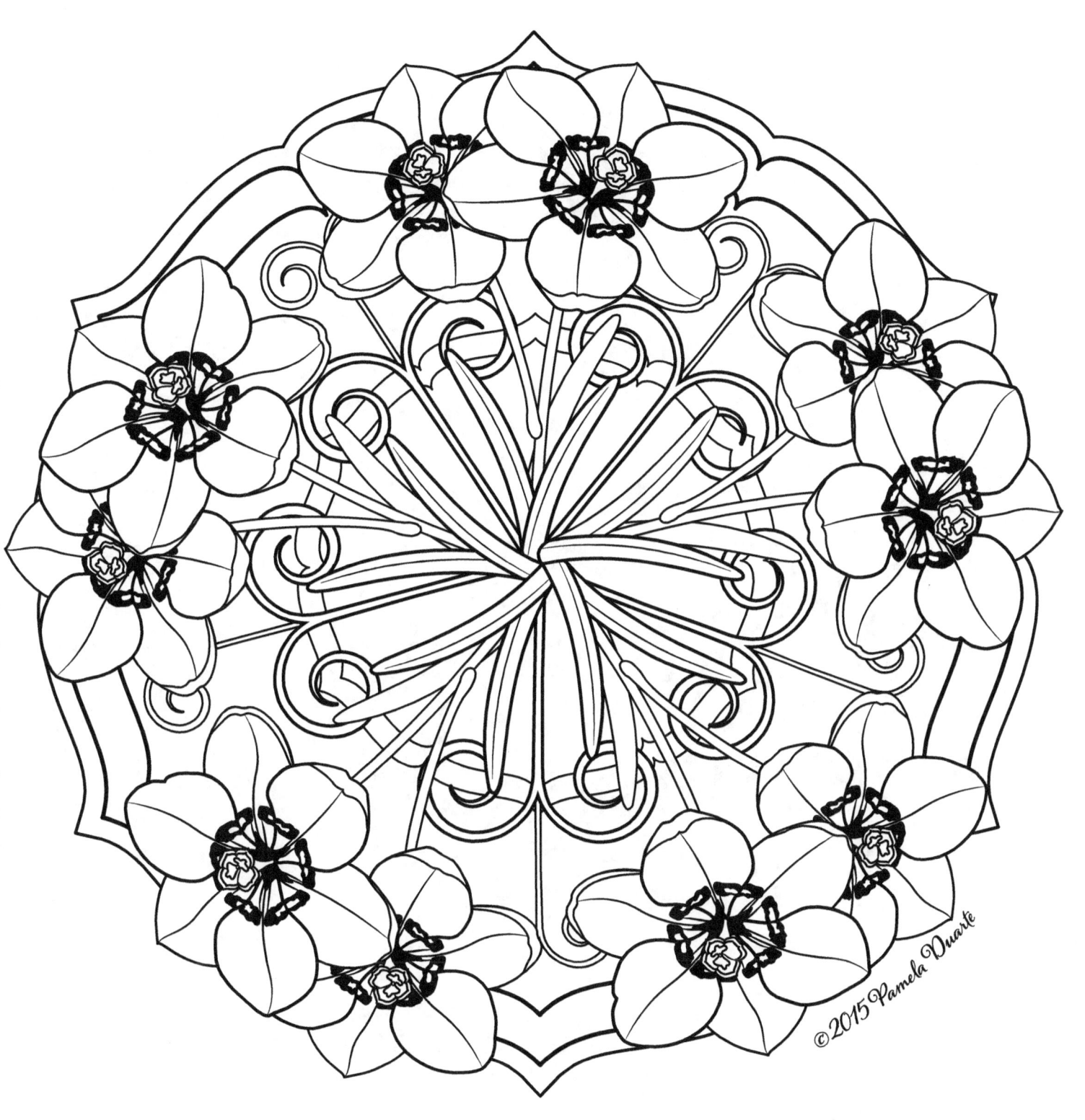

Harlequin Flower
Spraxix Elegans

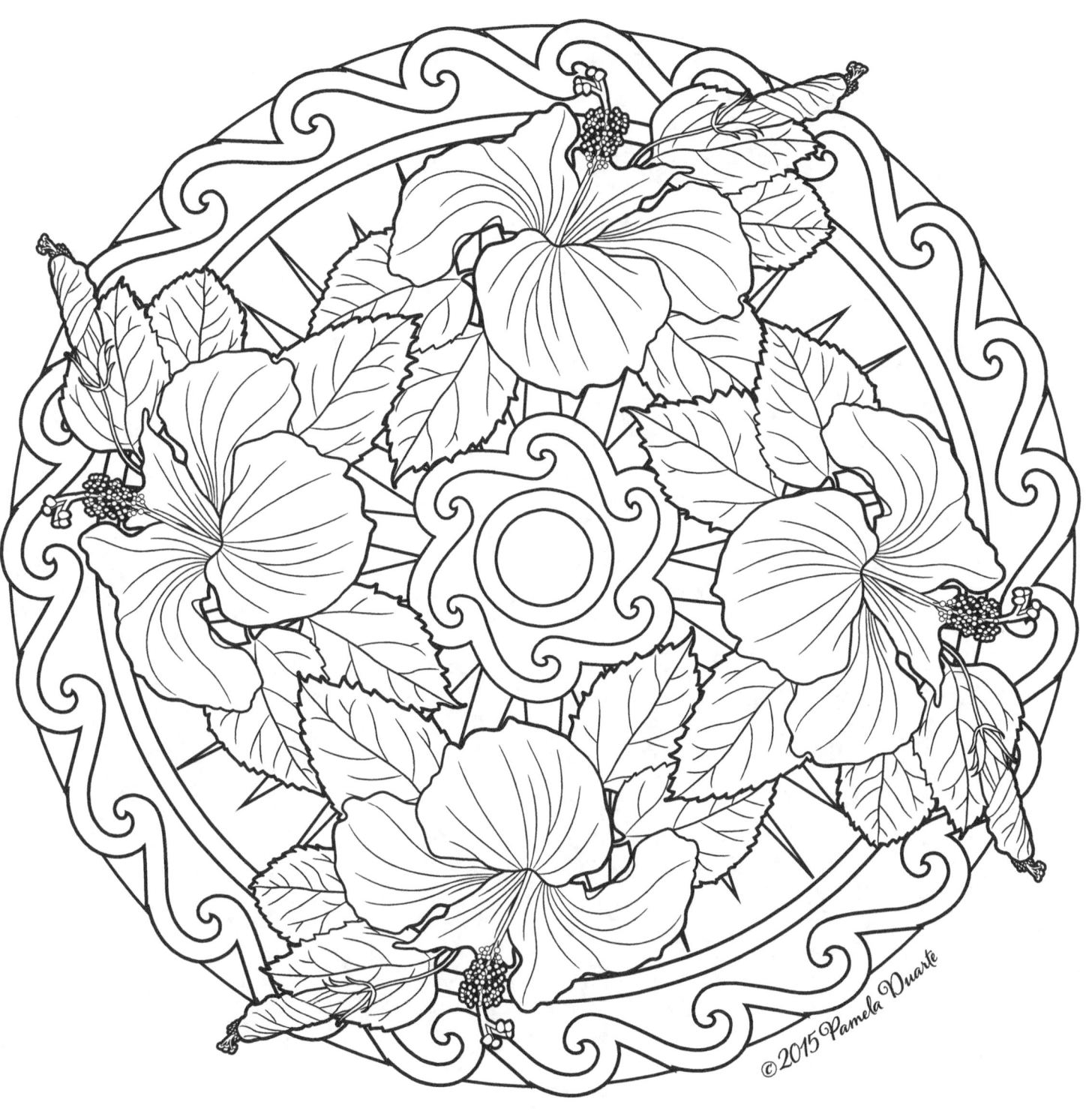

Hibiscus
Hibisceae

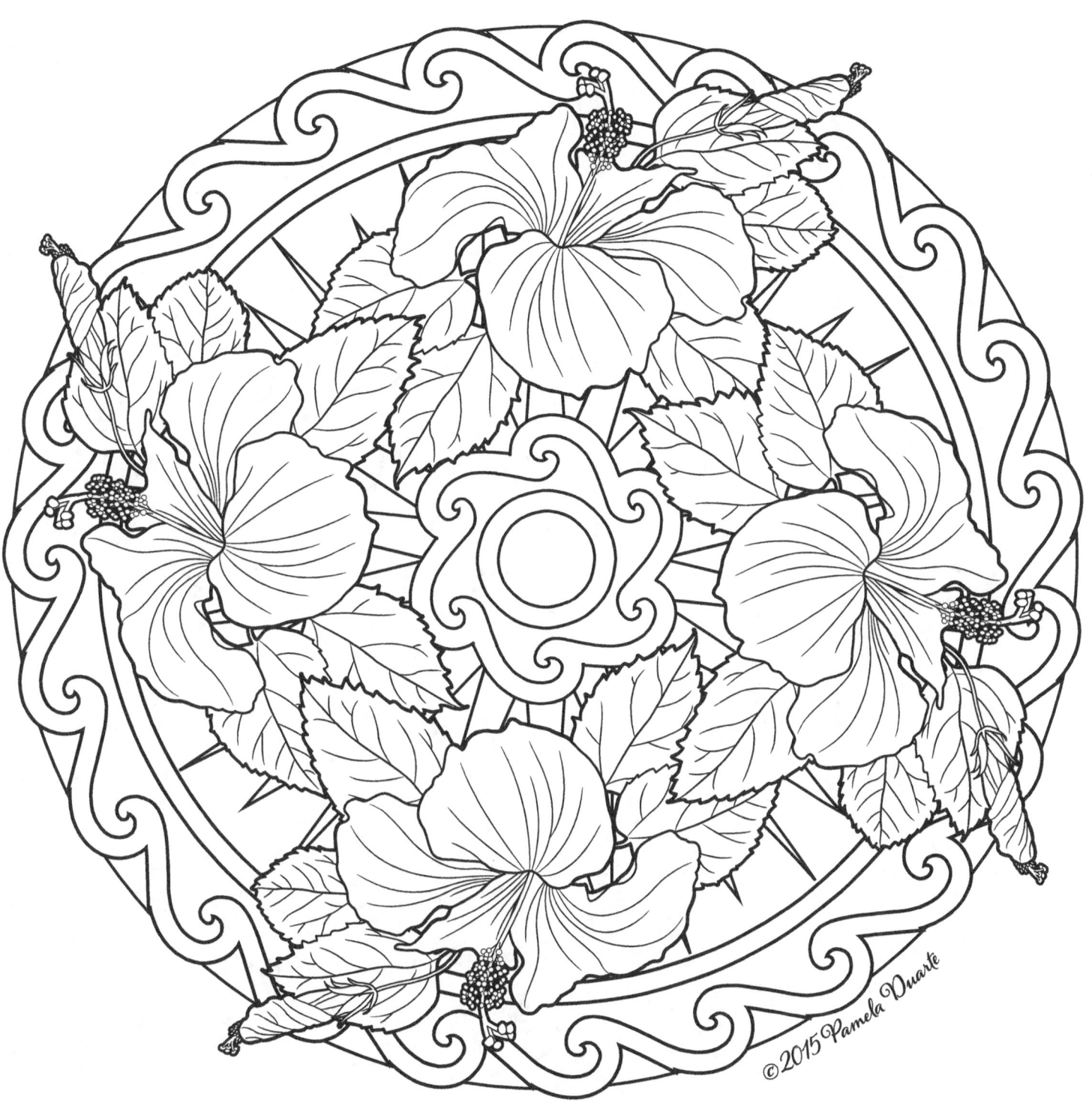

Hibiscus
Hibisceae

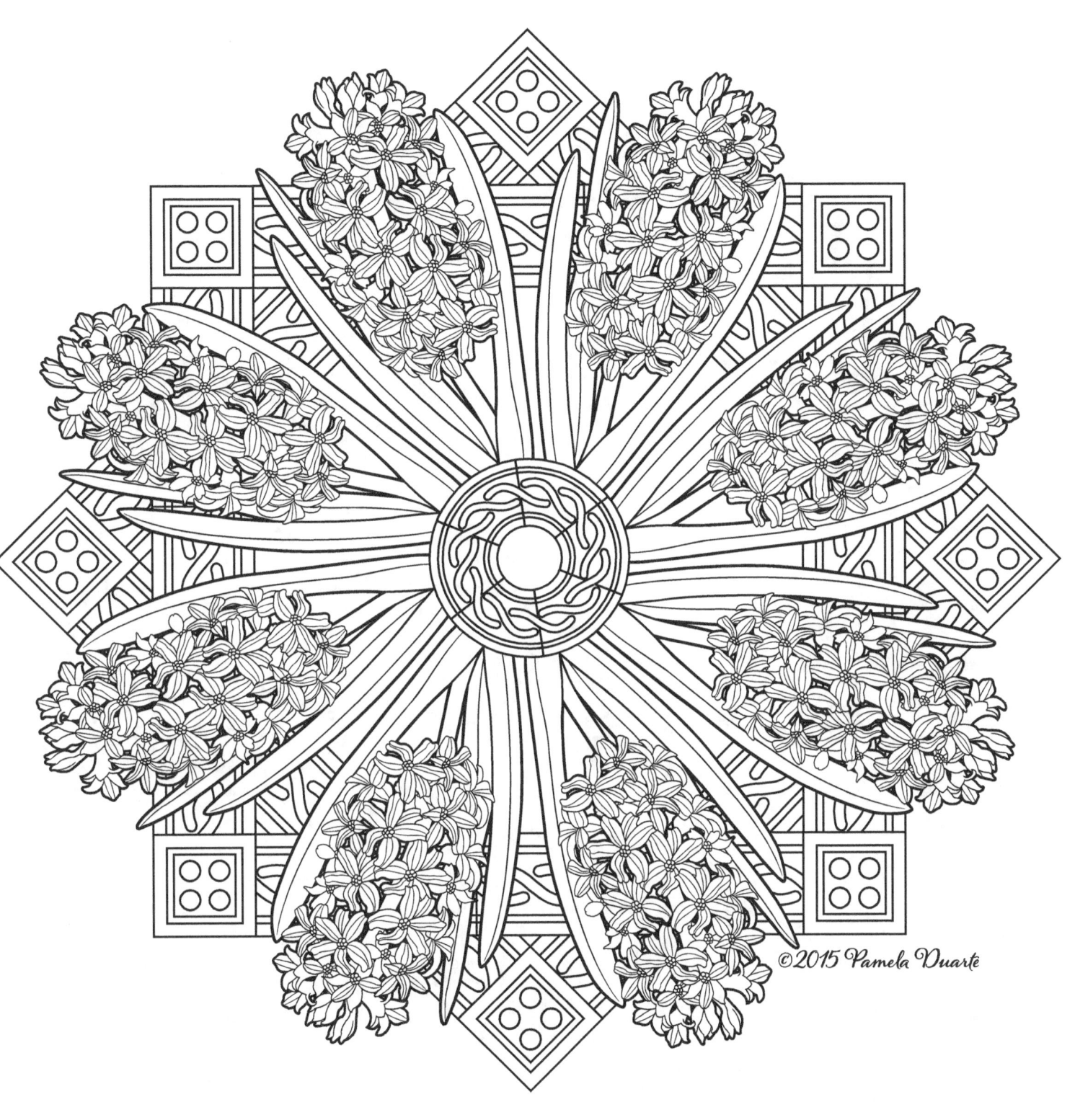

Hyacinth
Hyacinthus

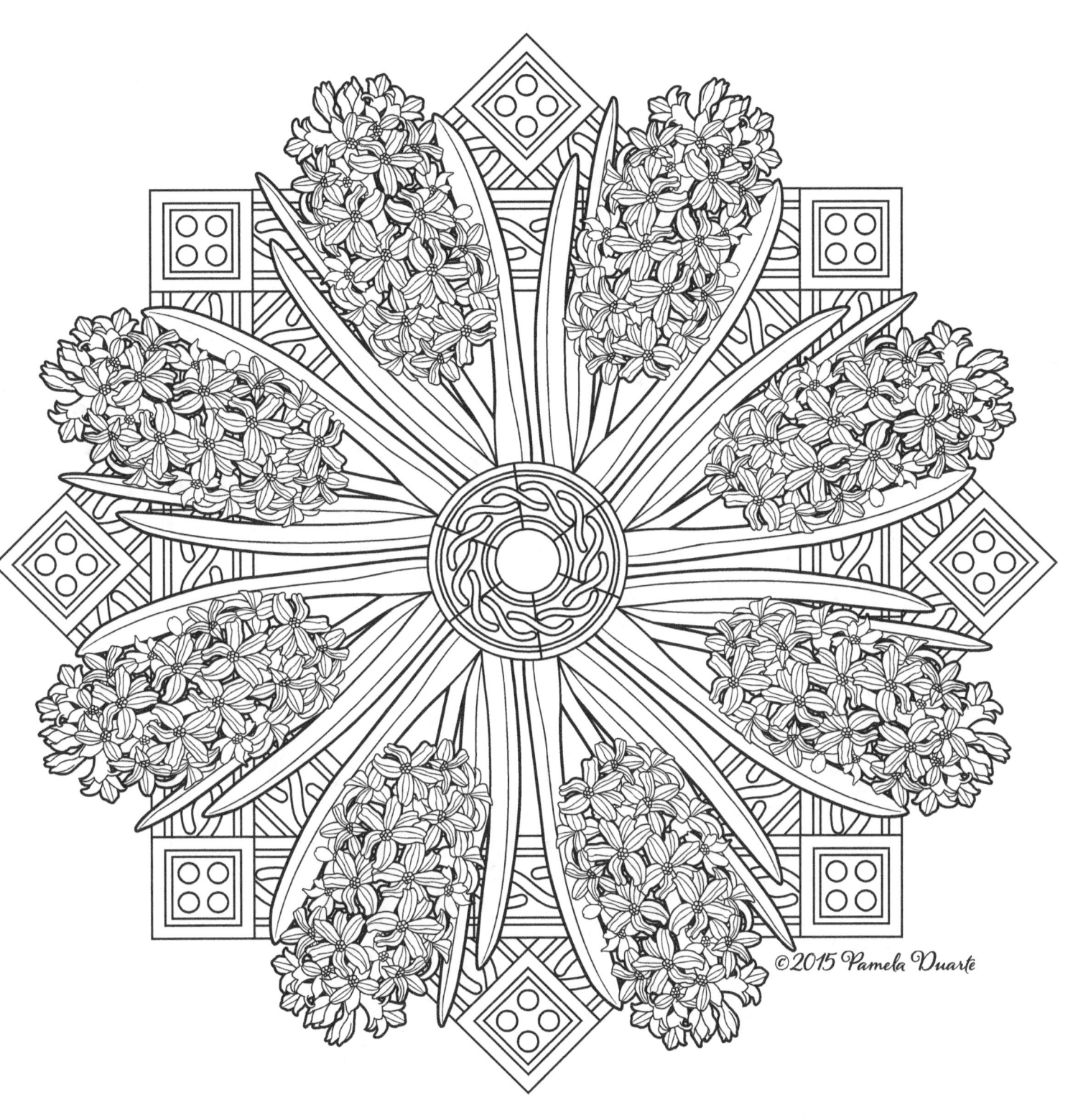

Hyacinth
Hyacinthus

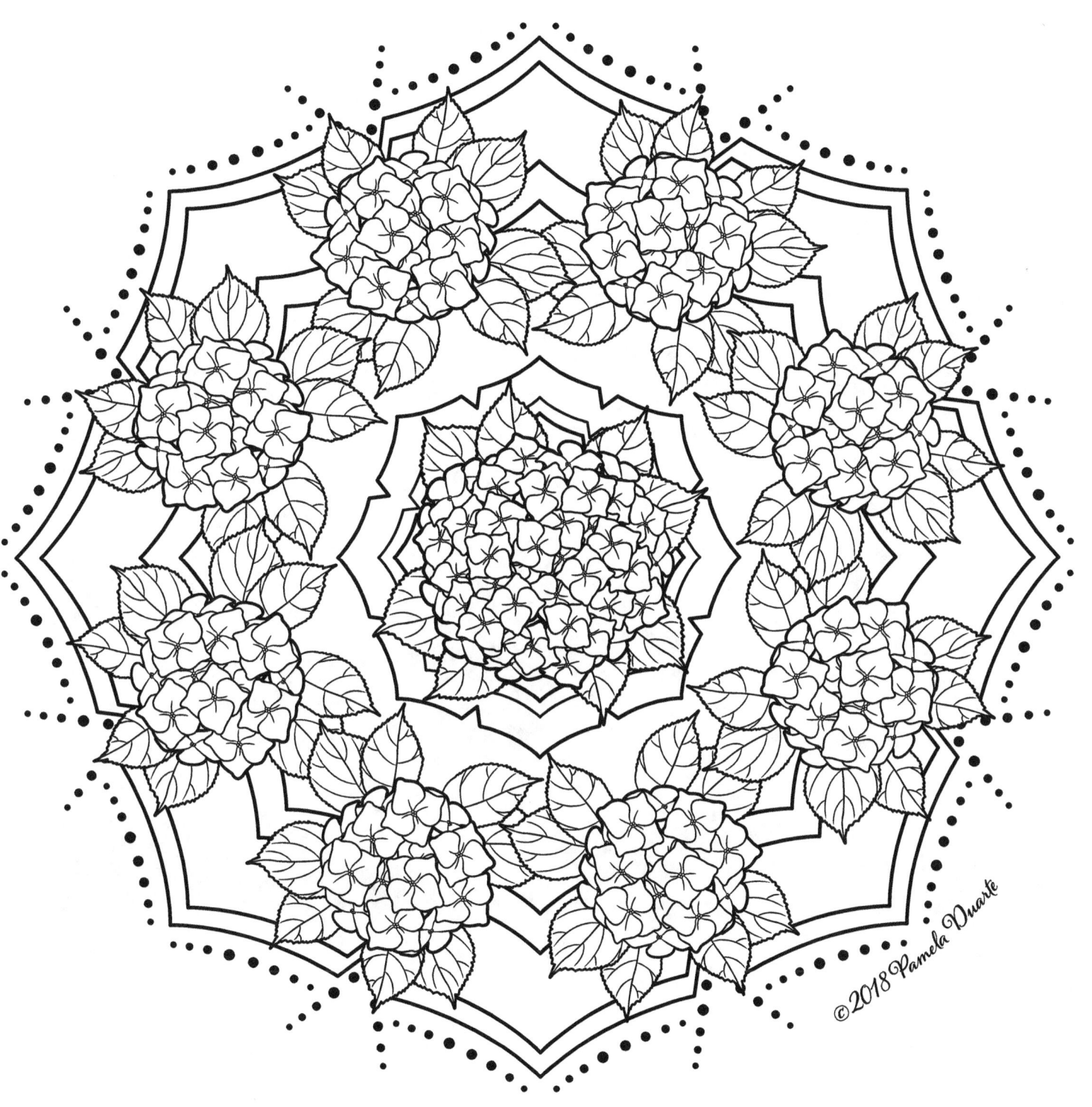

Hydrangea
Hydrangeaceae

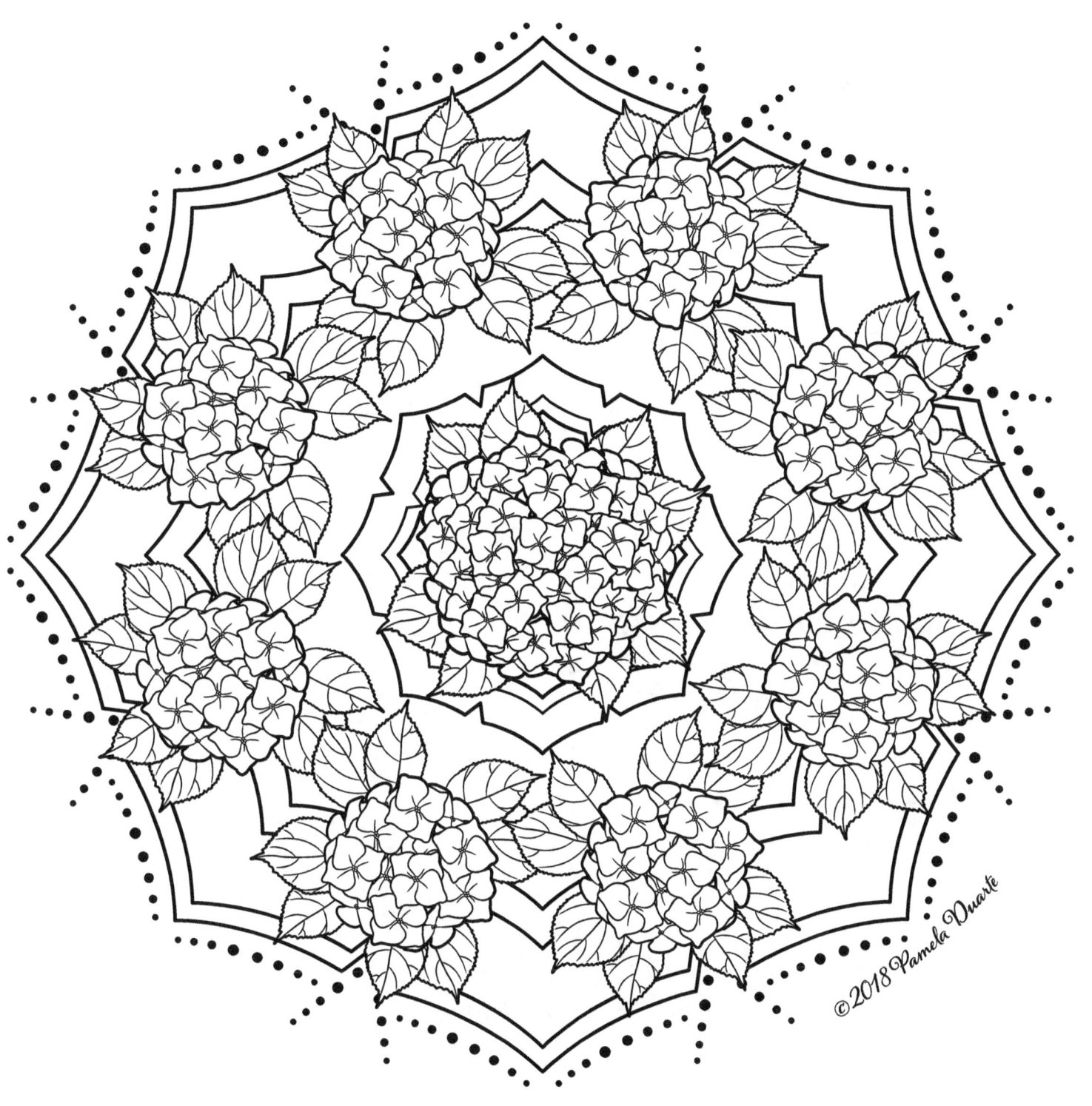

Hydrangea
Hydrangeaceae

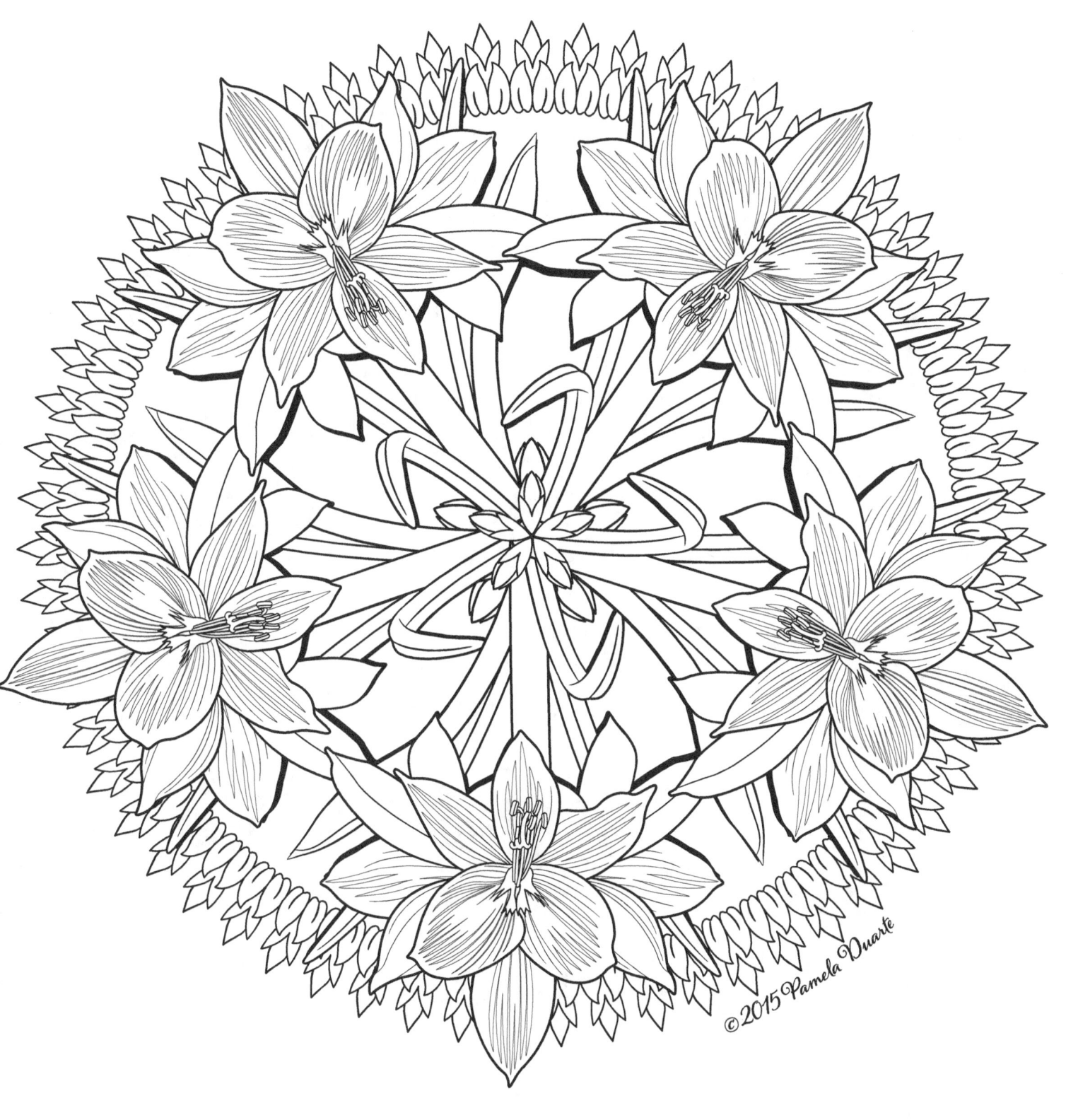

Knight's Star Lily
Hippeastrum

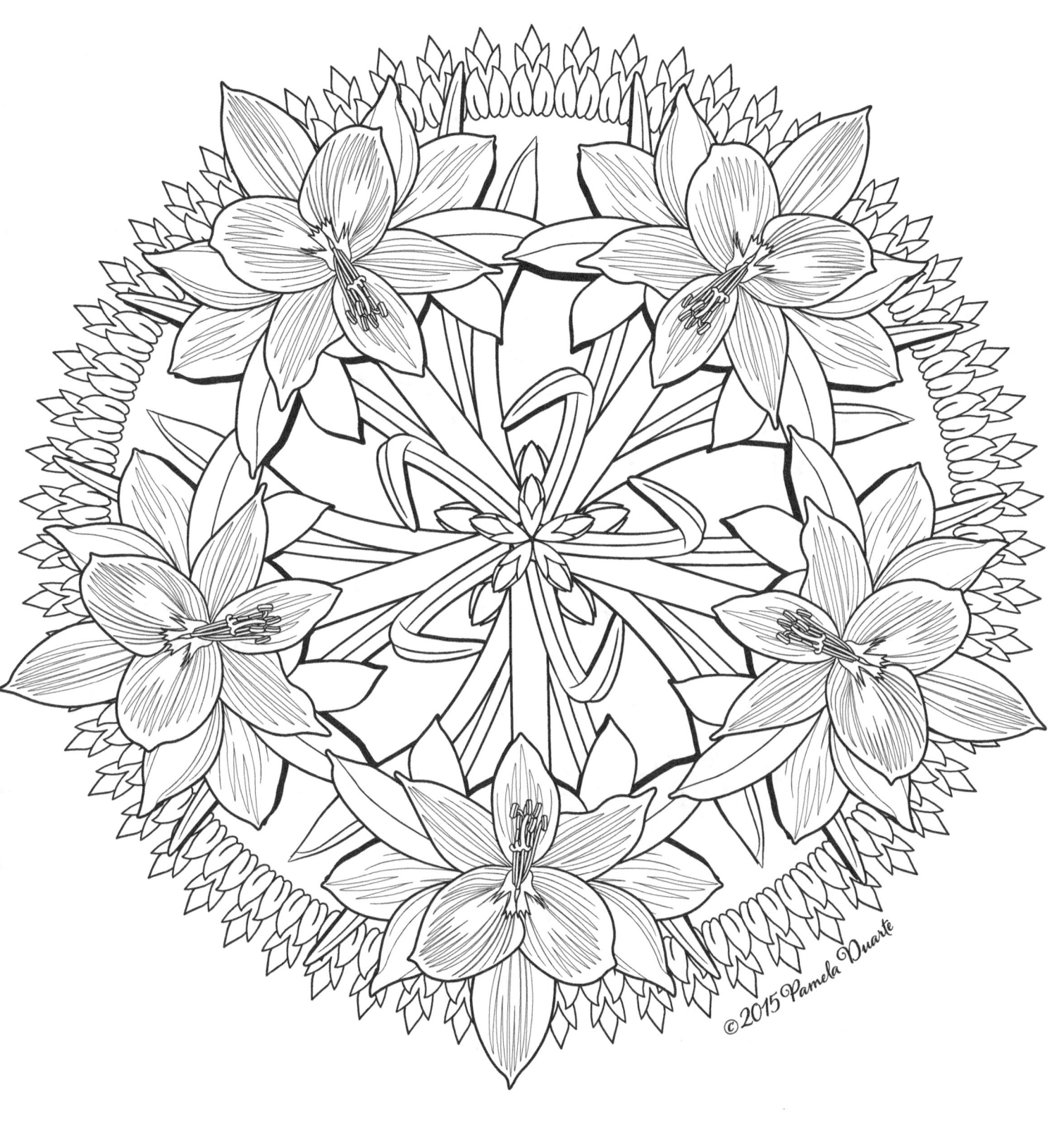

Knight's Star Lily

Hippeastrum

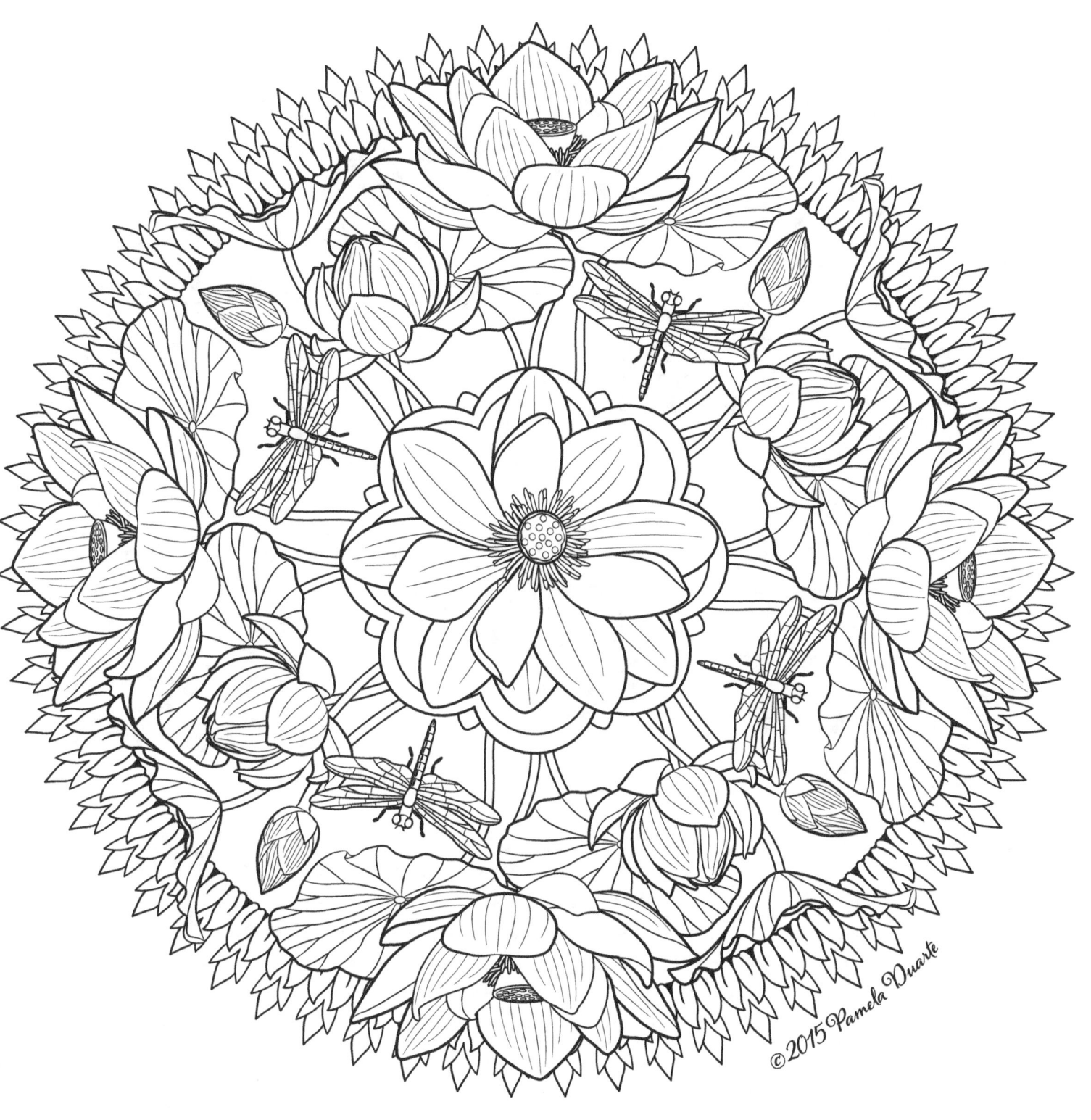

Lotus
Nelumbo nucifera

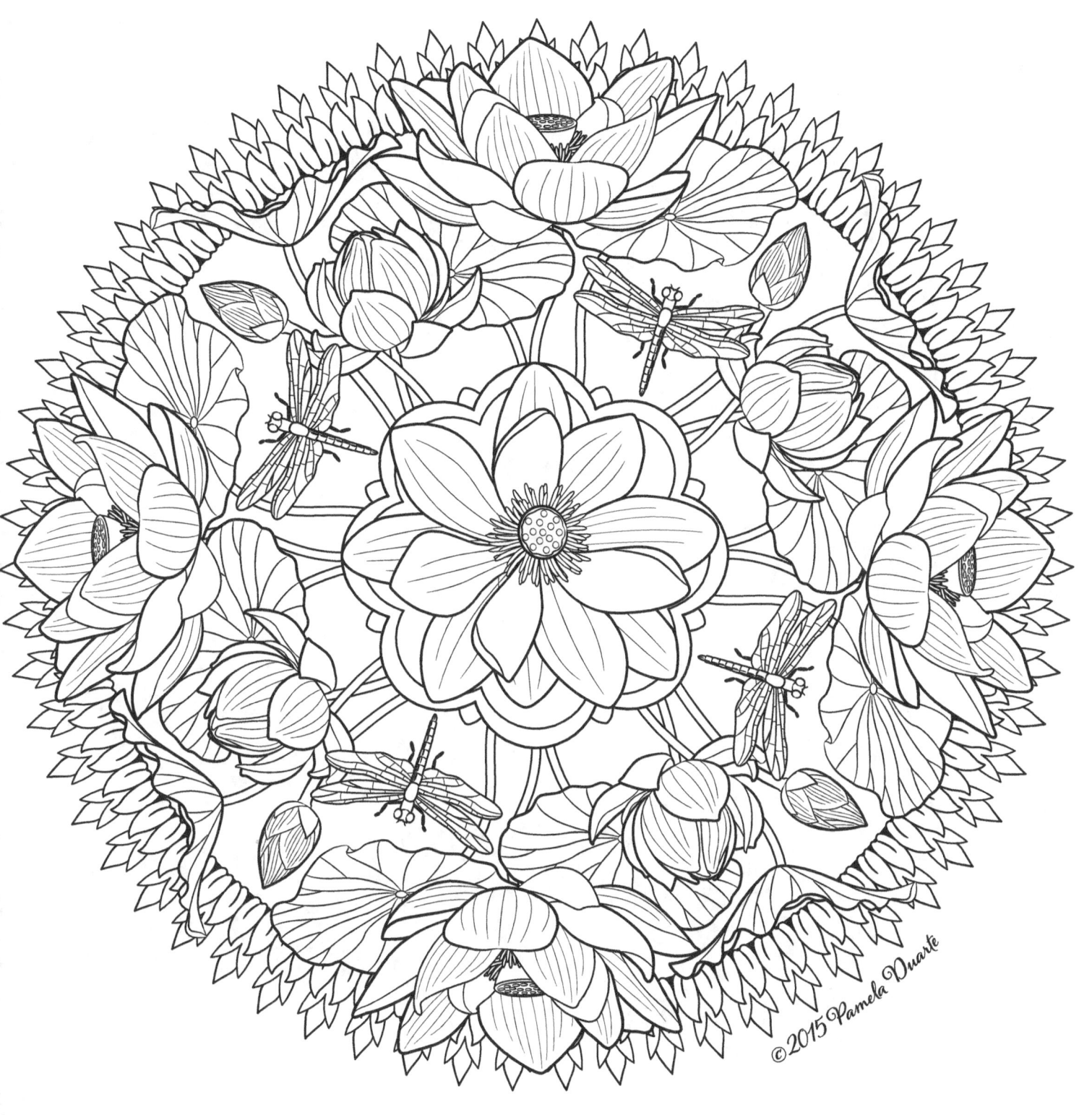

Lotus
Nelumbo nucifera

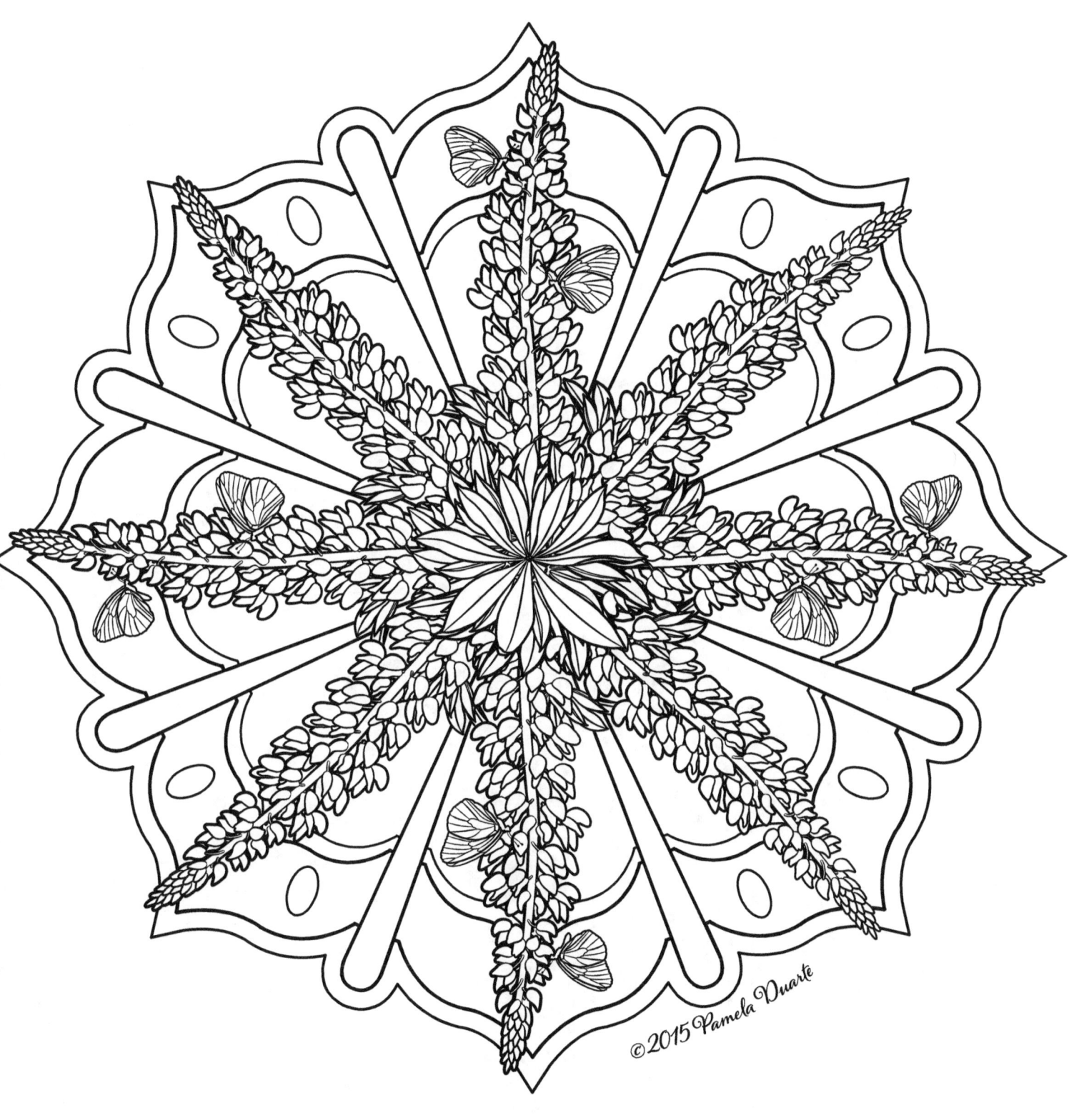

Lupine
Lupinus

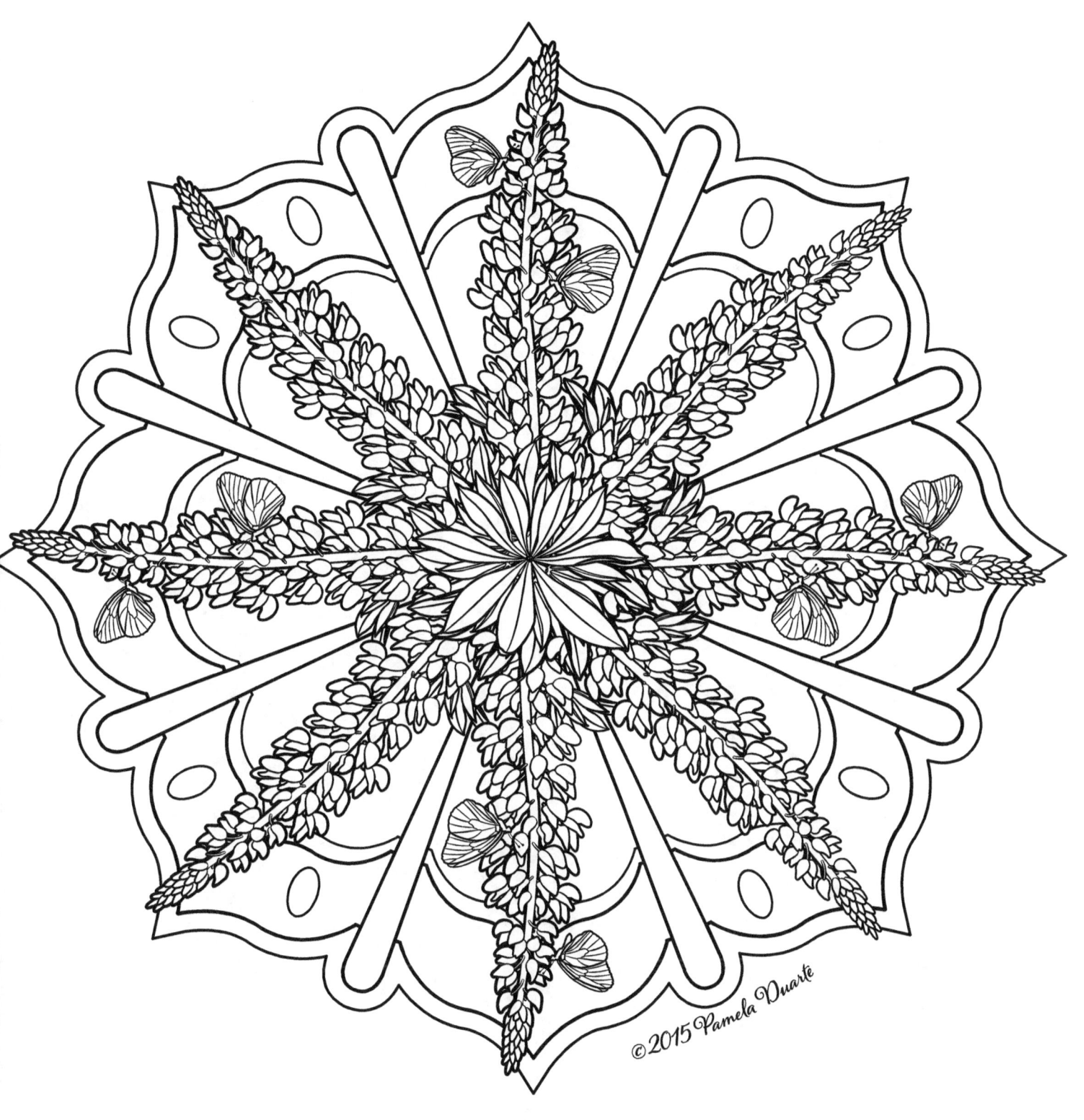

Lupine
Lupinus

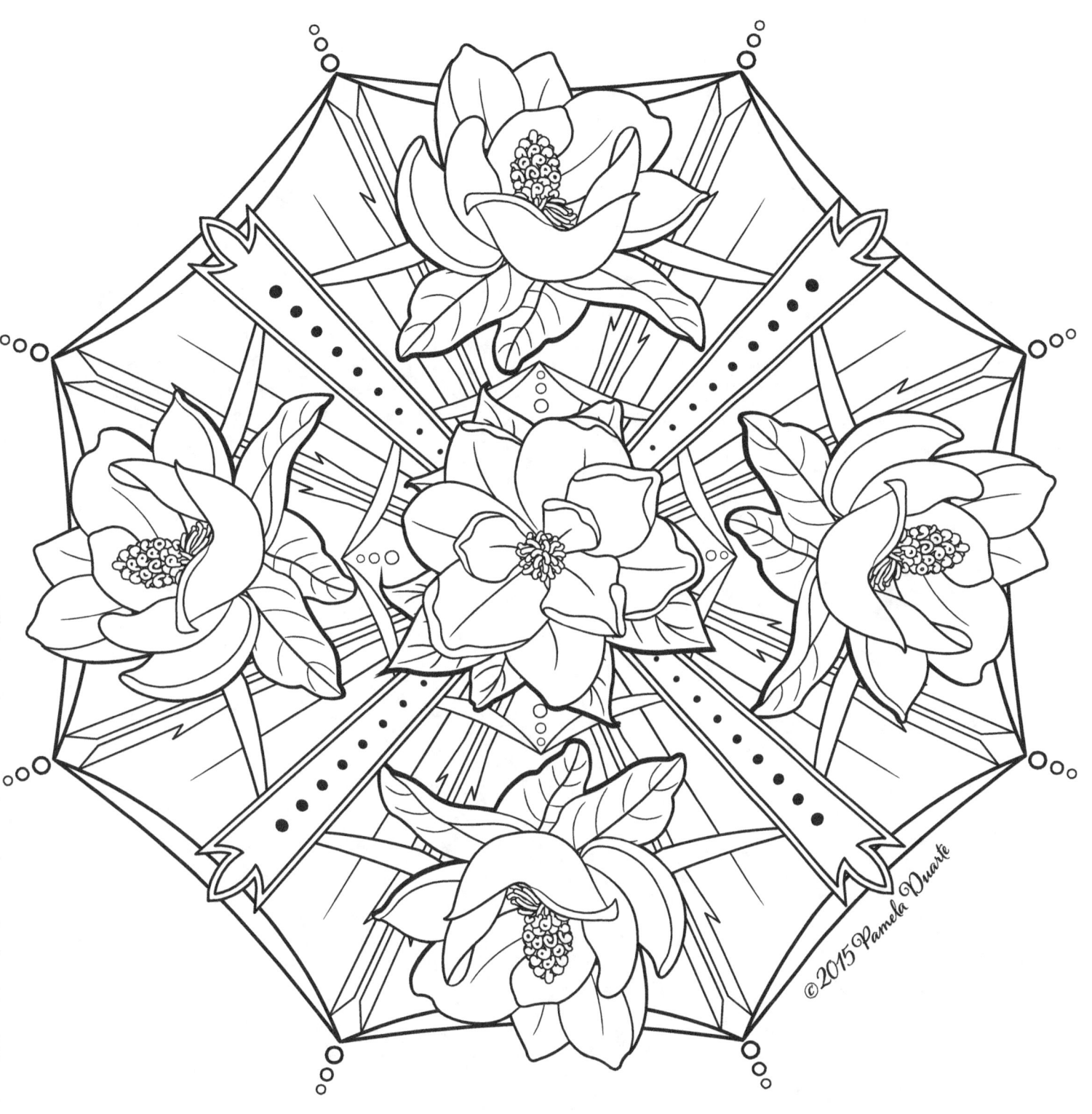

Magnolia
Magnoliaceae

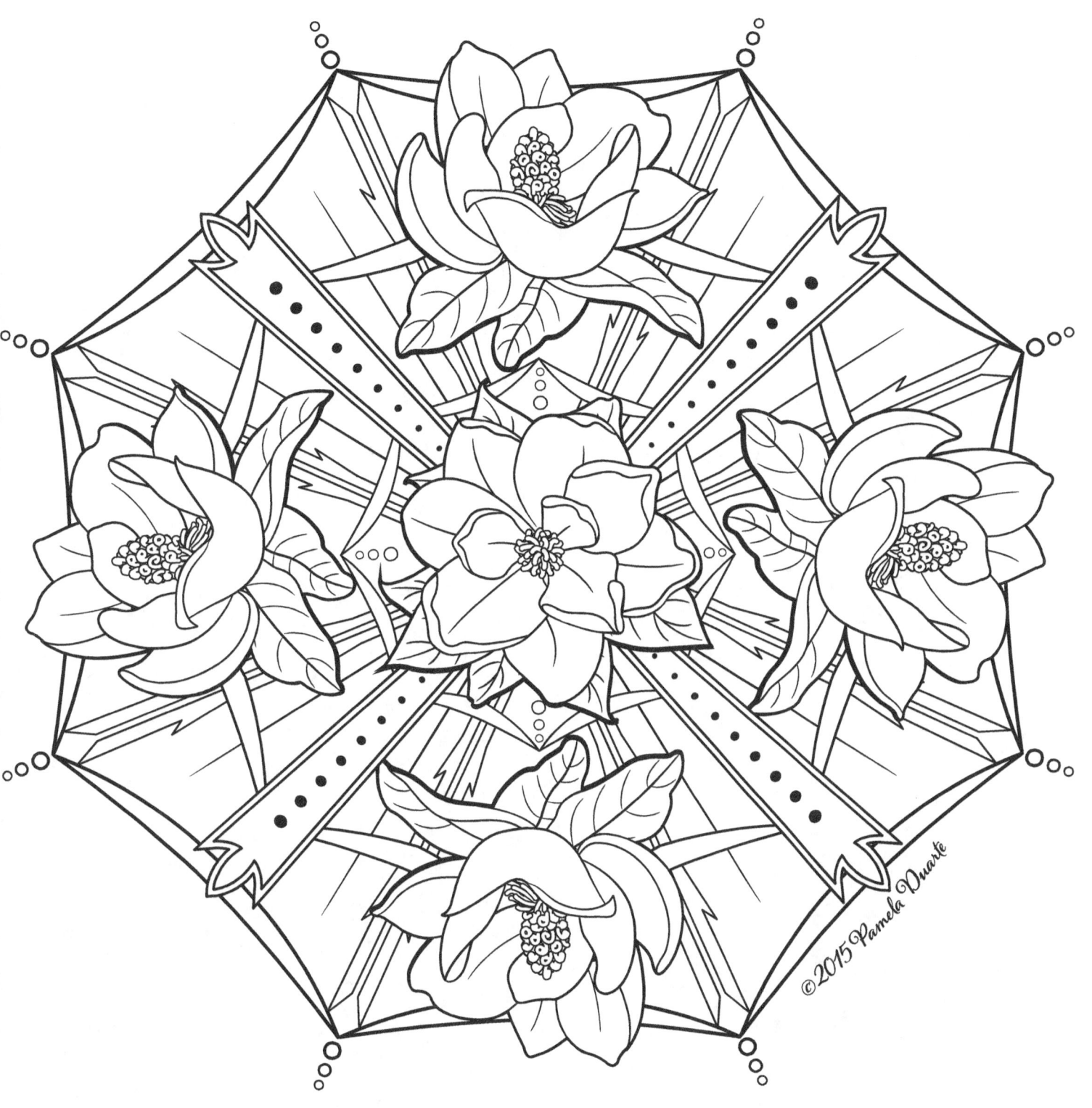

Magnolia
Magnoliaceae

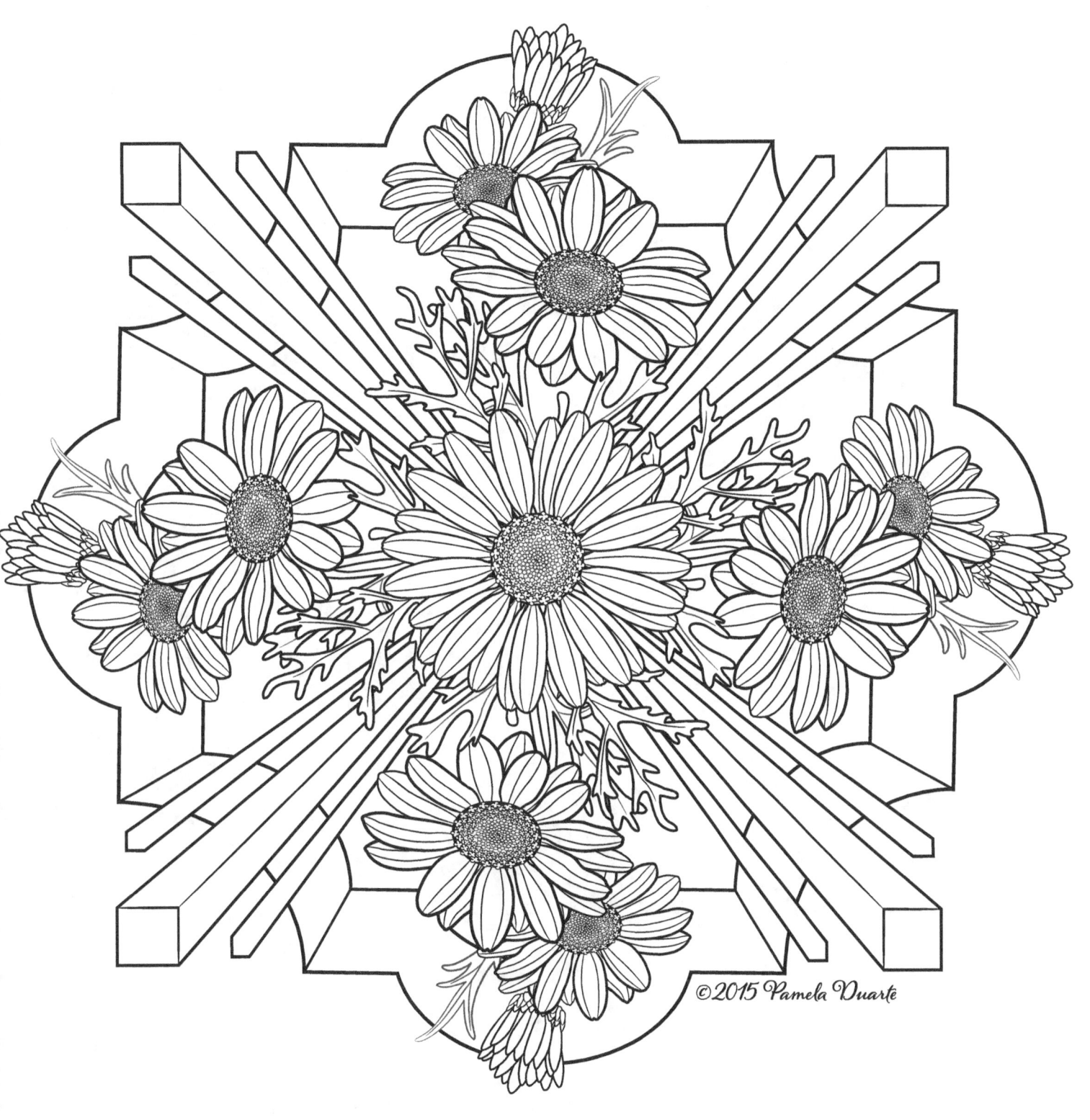

Marguerite Daisy
Argyranthemum frutescens

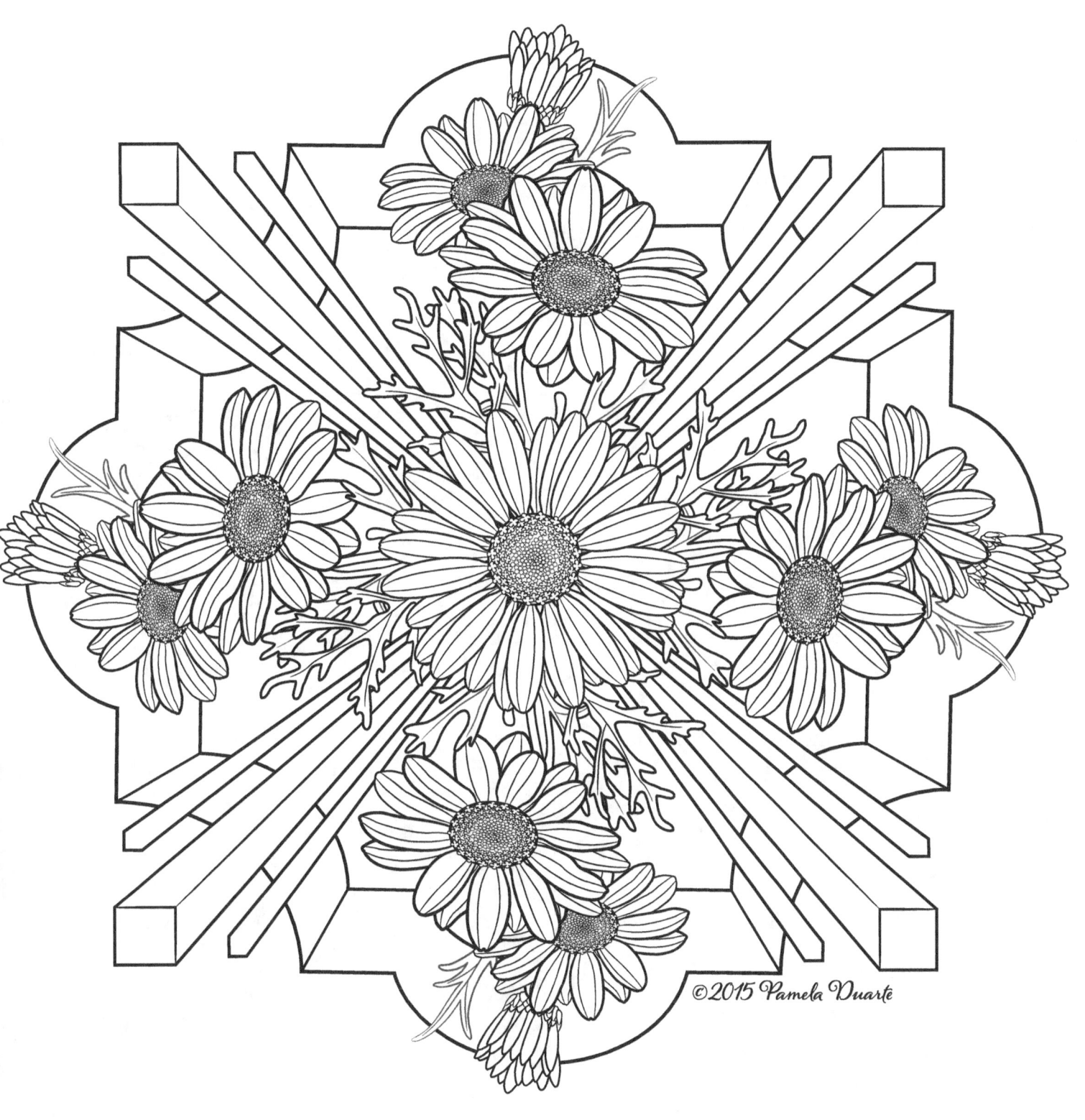

Marguerite Daisy
Argyranthemum frutescens

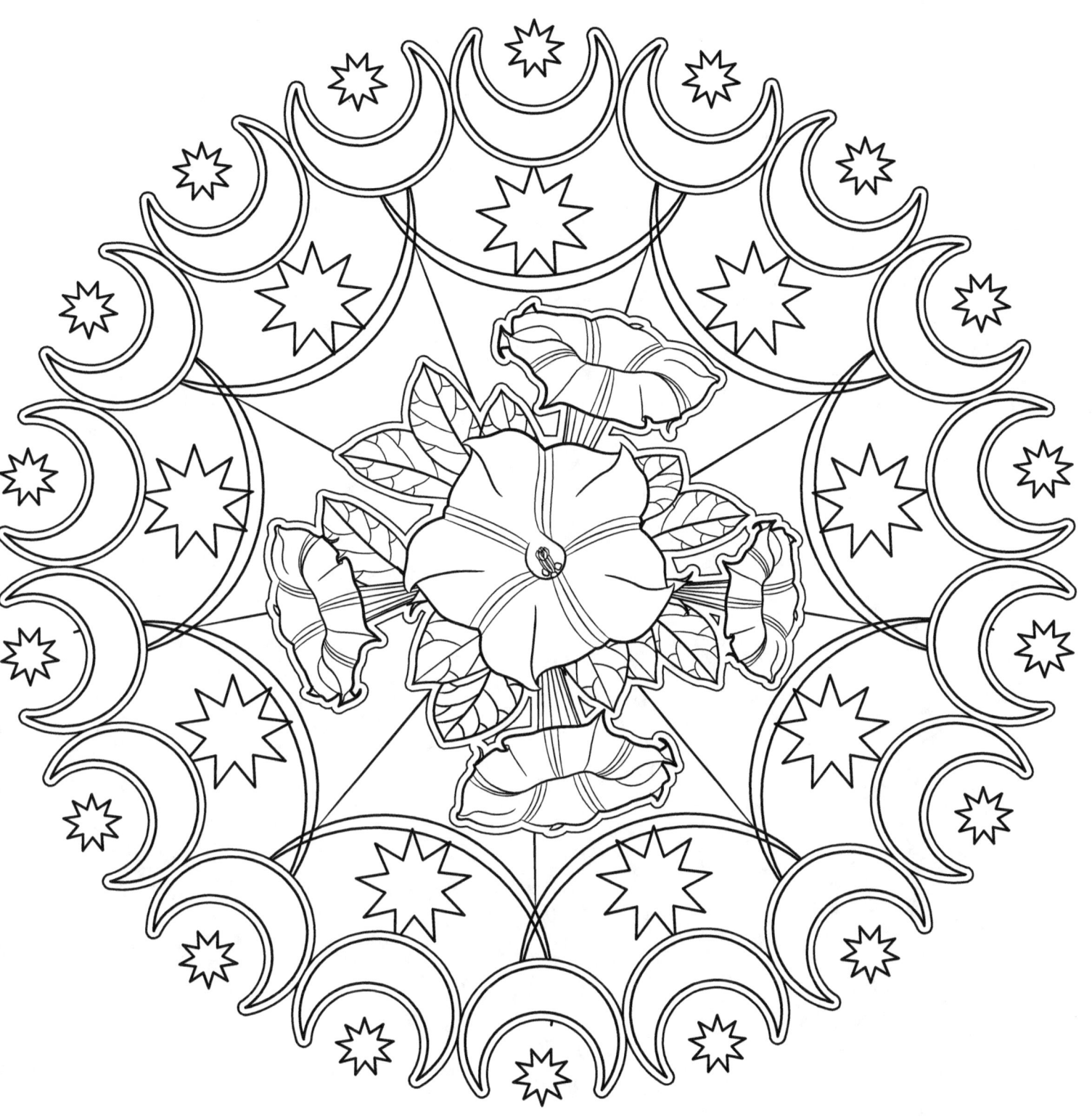

Moon Flower
Ipomoea

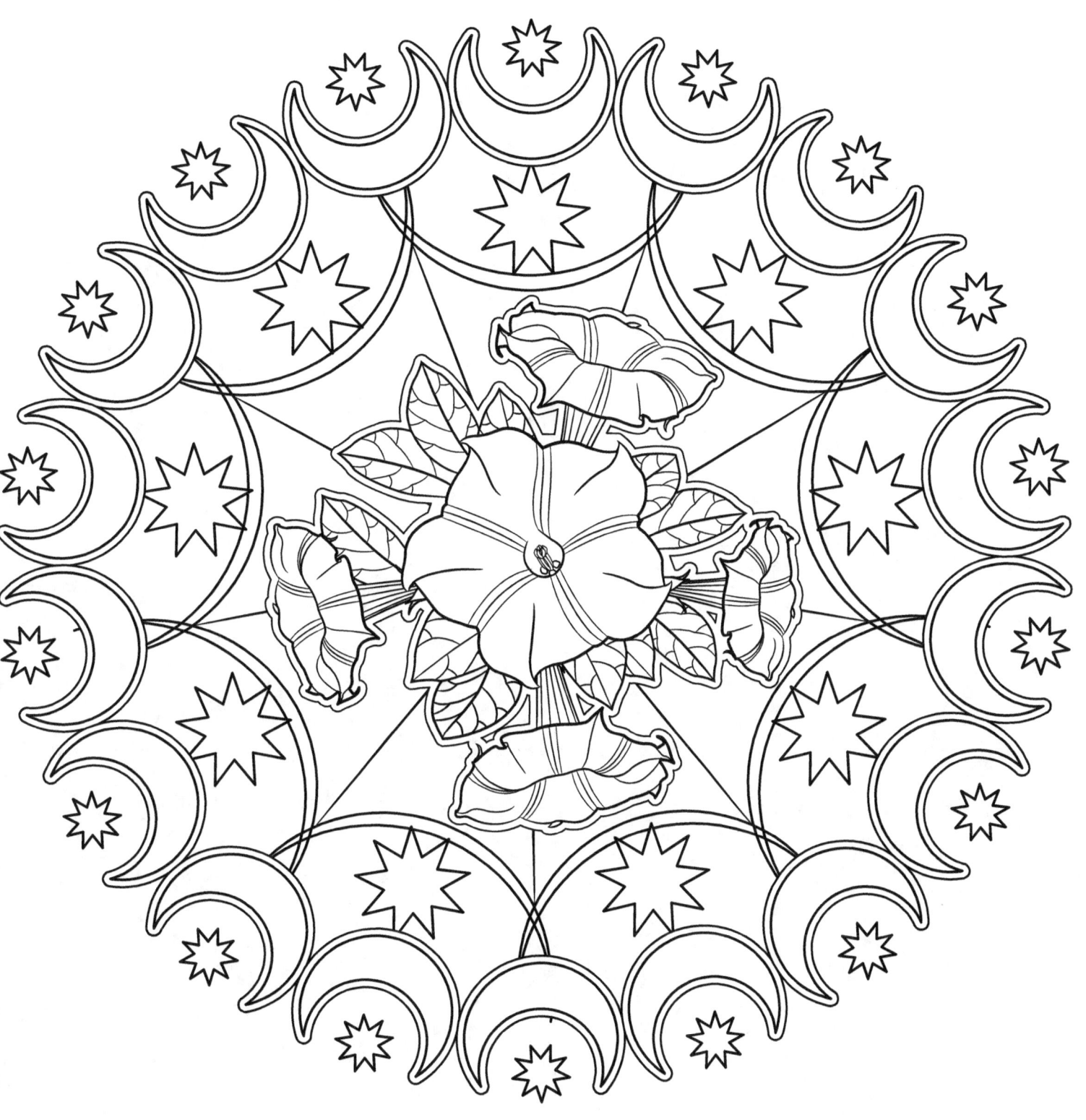

Moon Flower
Ipomoea

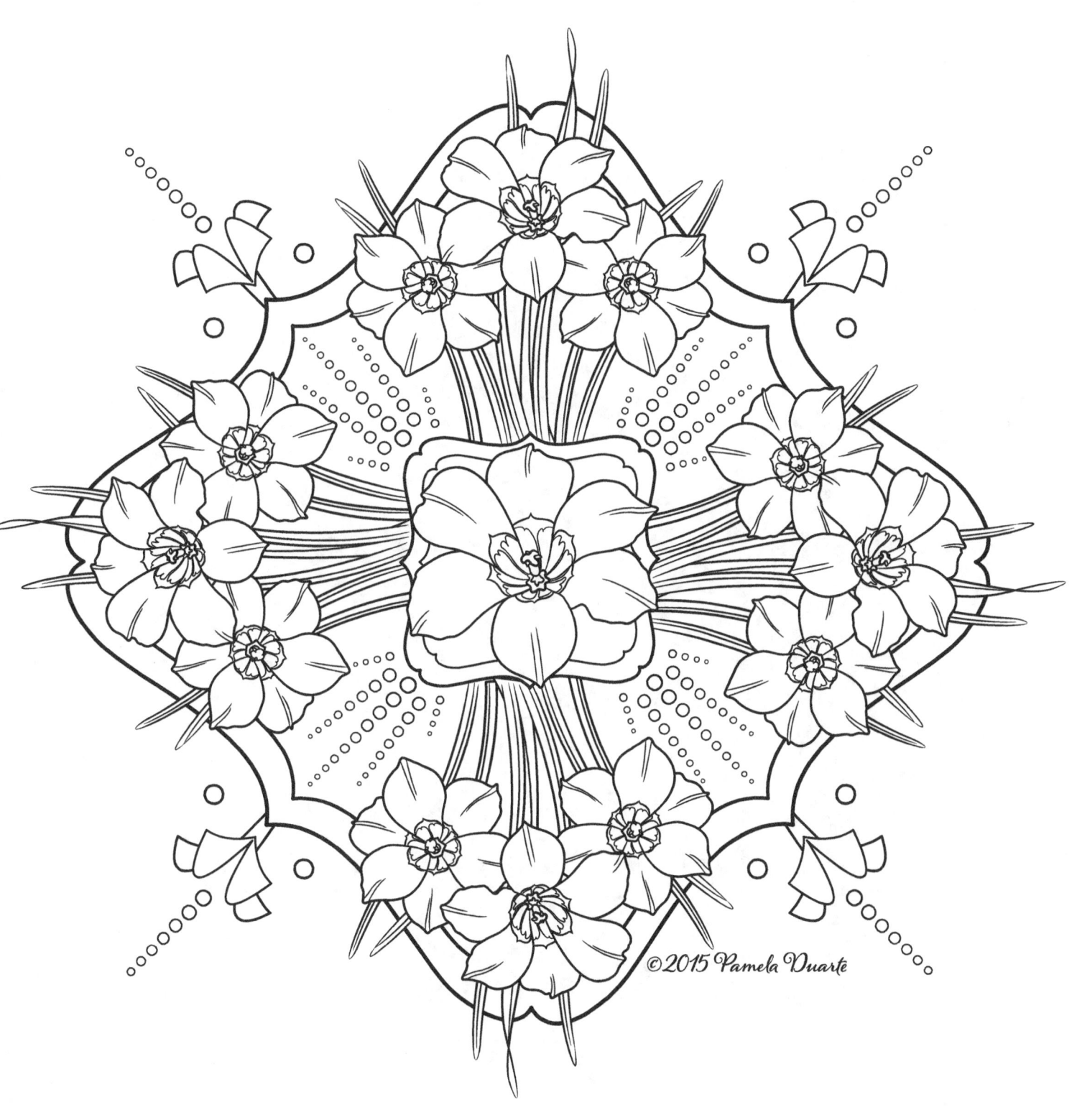

Moraea
Iridaceae

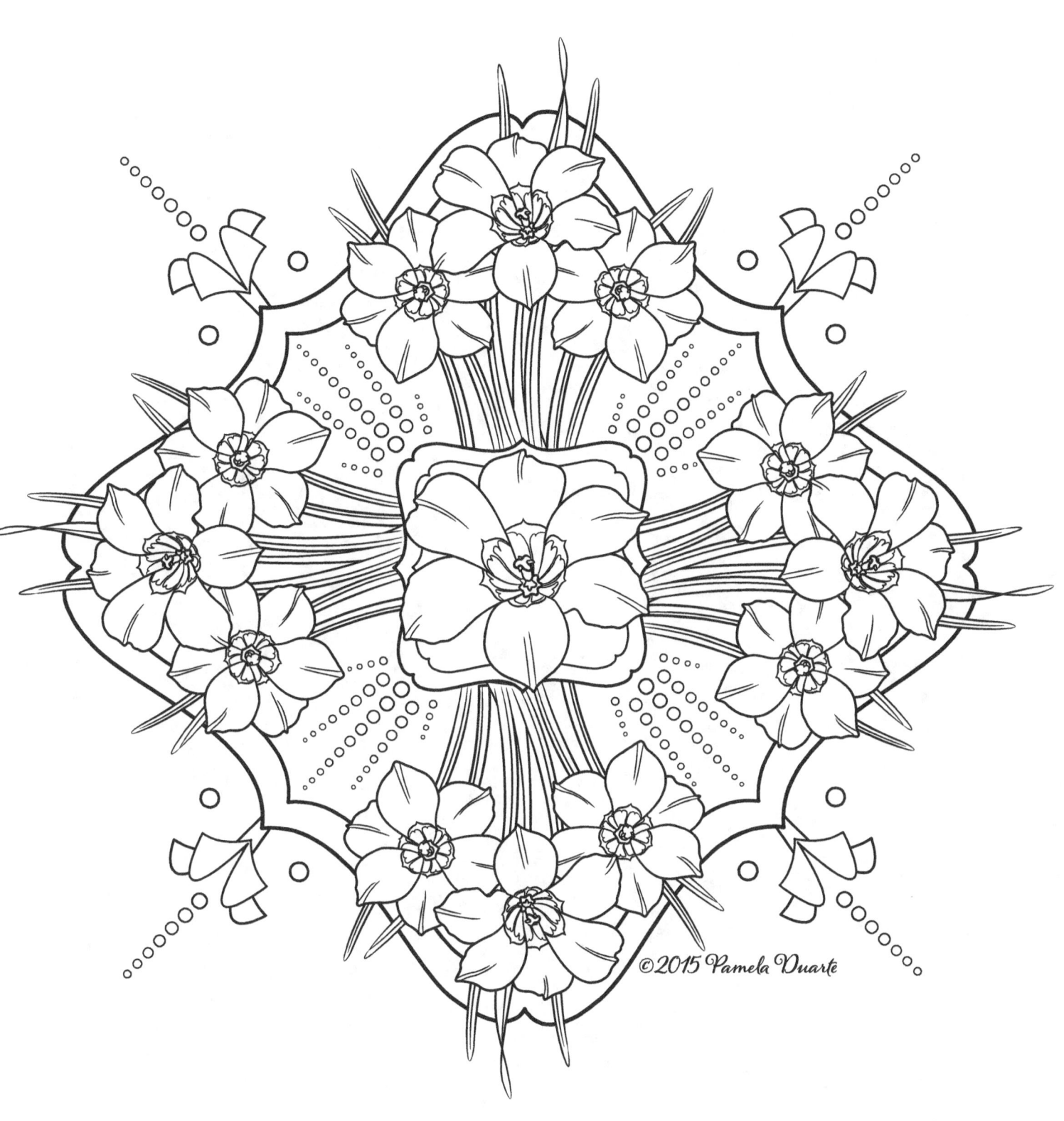

Moraea
Iridaceae

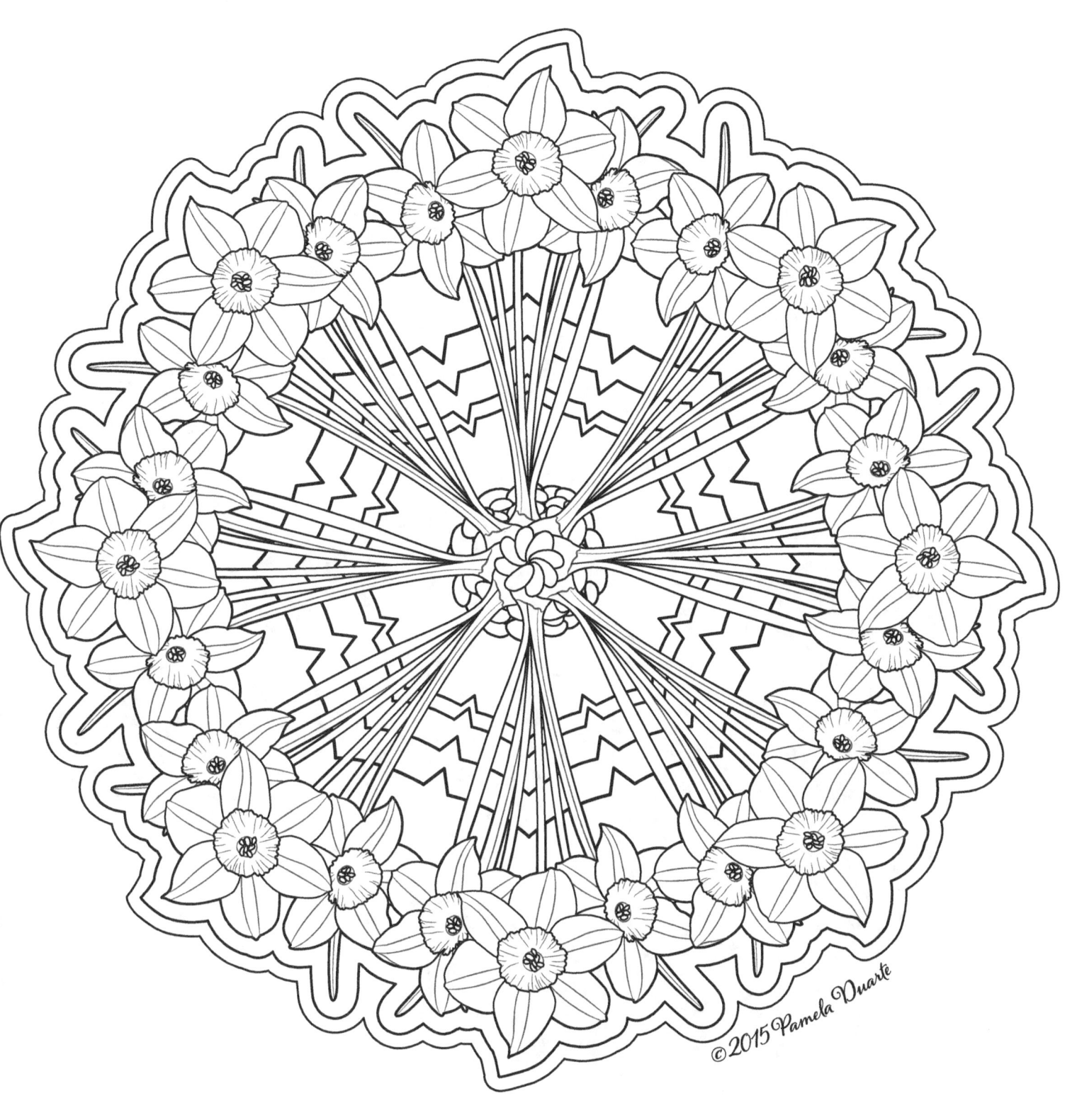

Daffodil
Narcissus

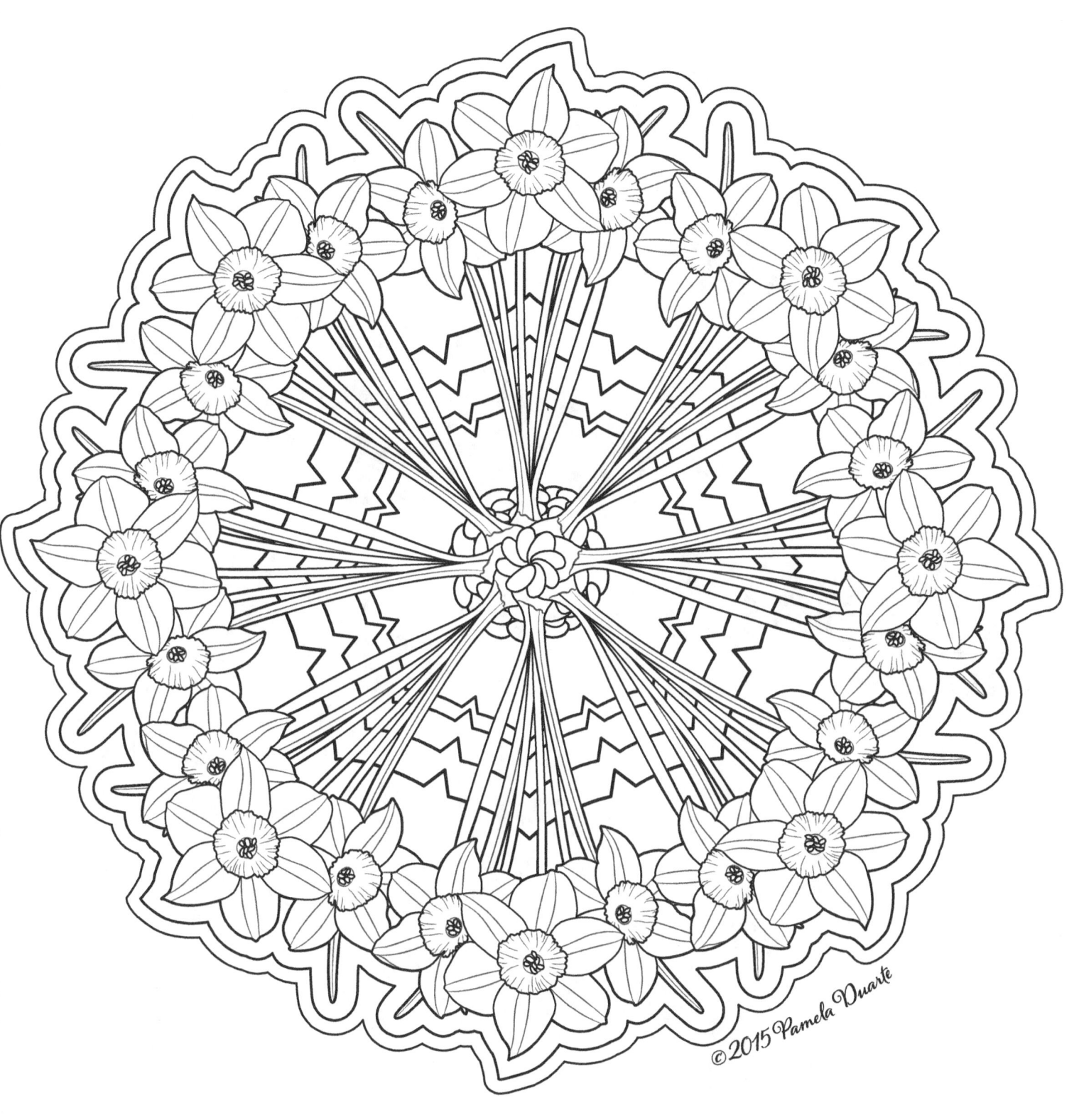

Daffodil
Narcissus

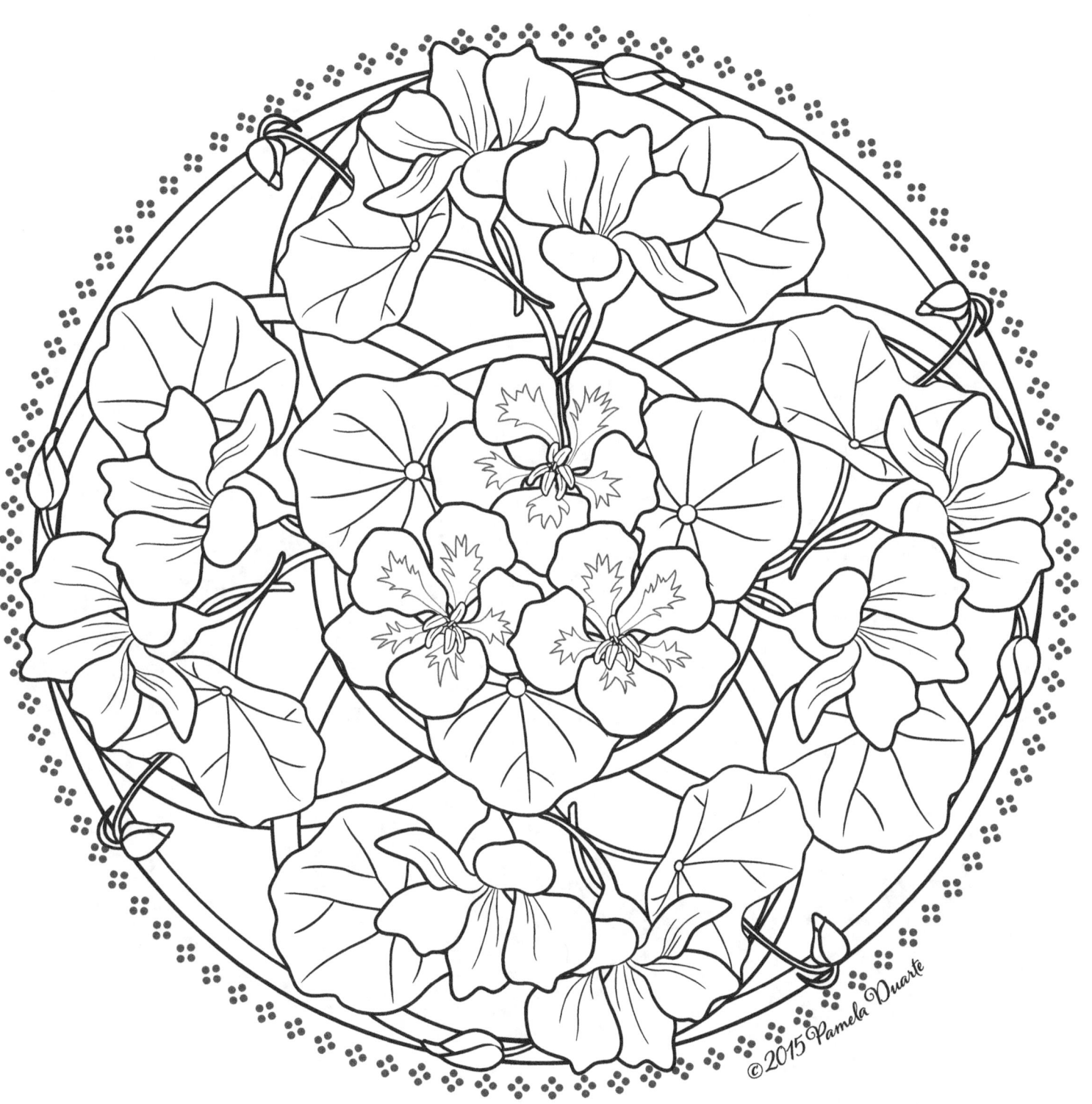

Nasturtium
Tropaeolum

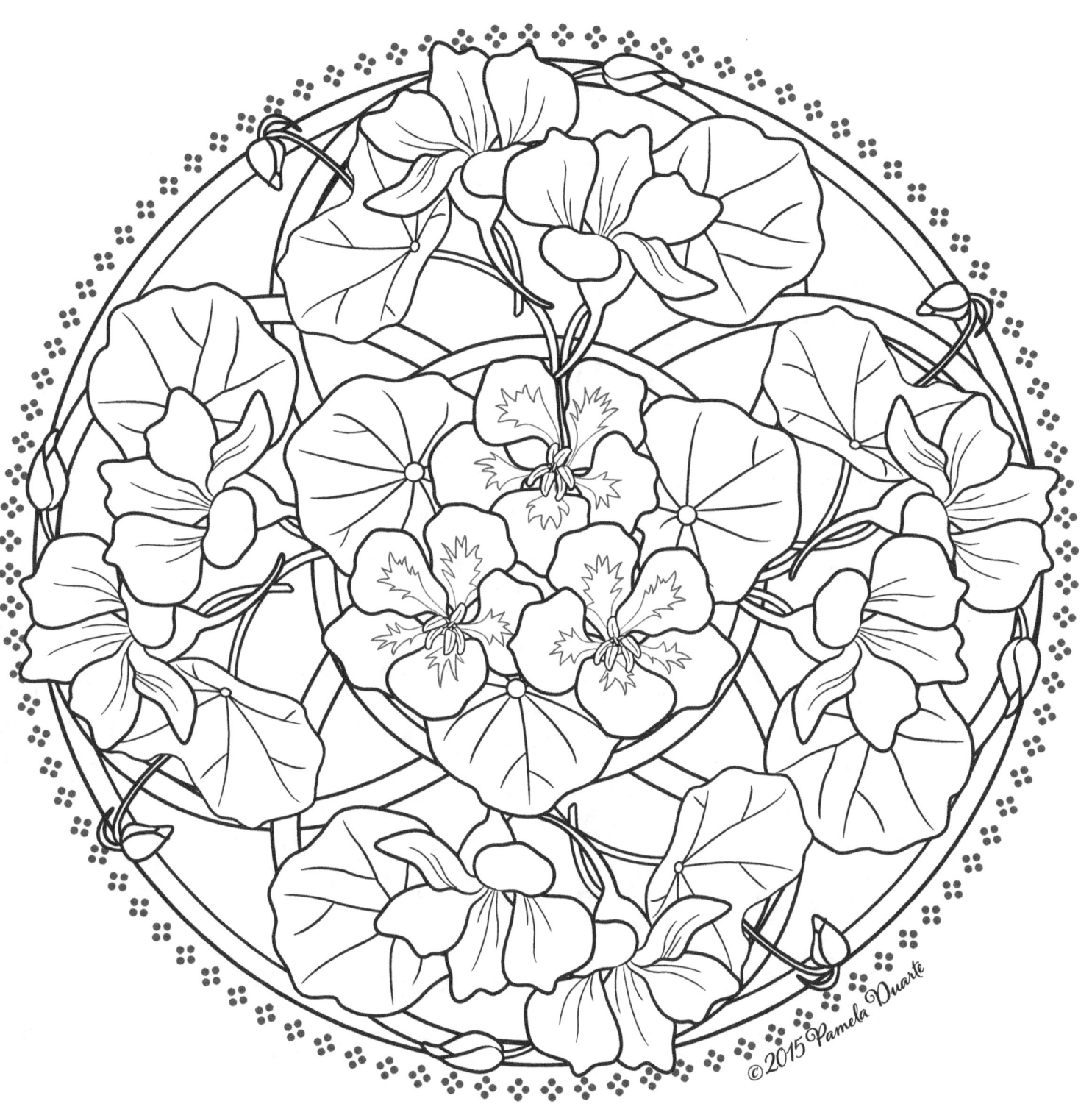

Nasturtium
Tropaeolum

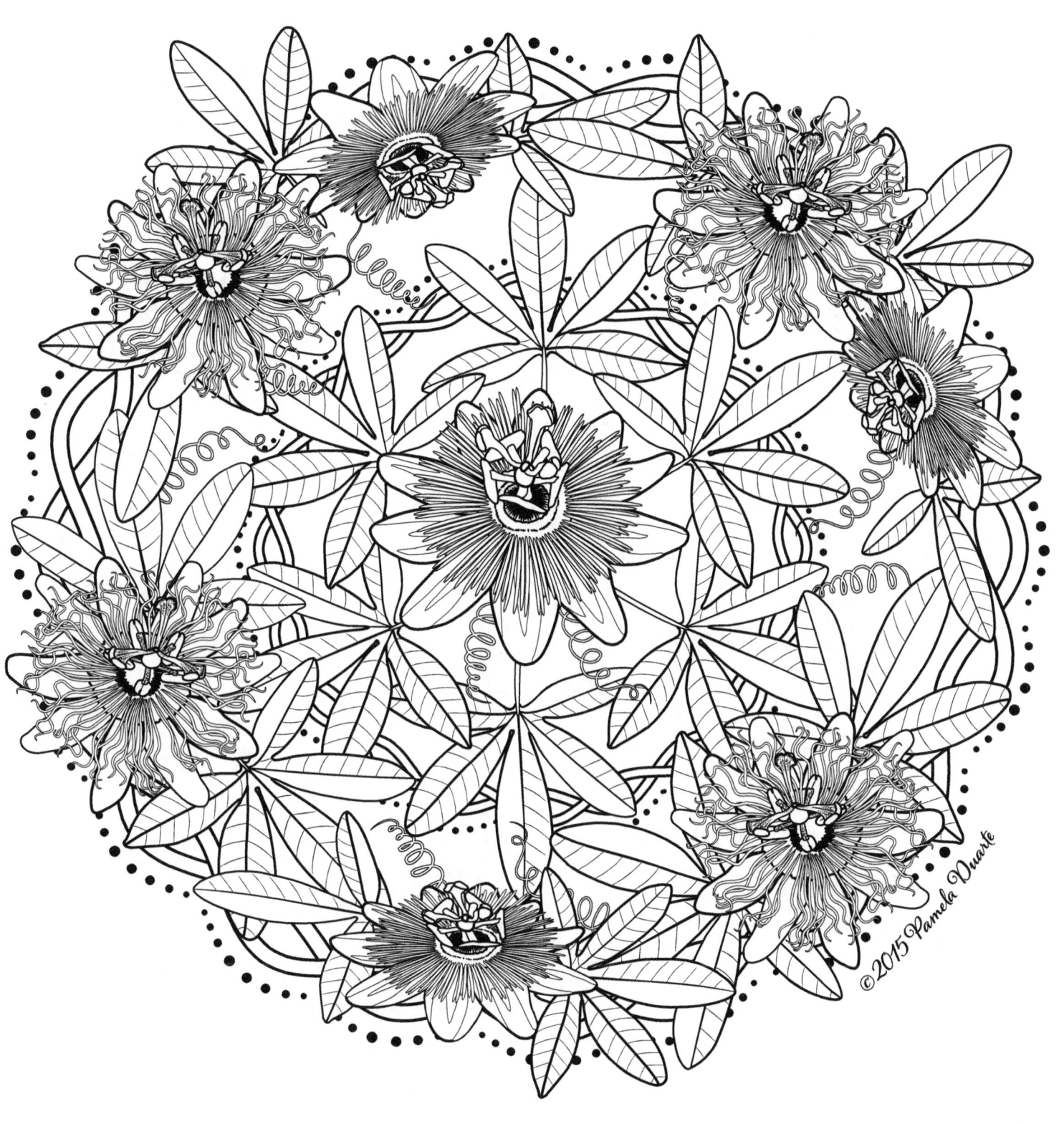

Passion Flower
Passifloraceae

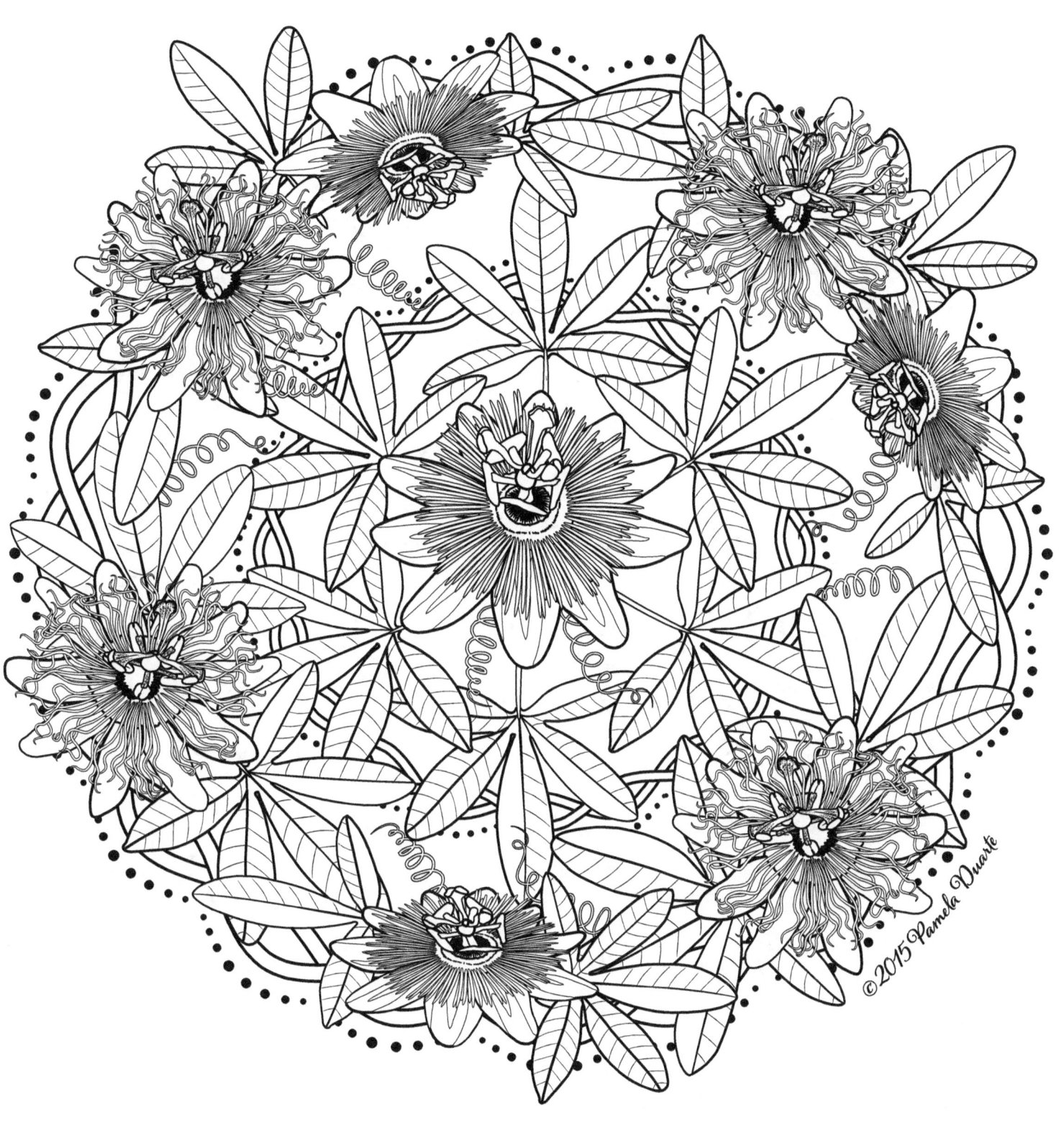

Passion Flower
Passifloraceae

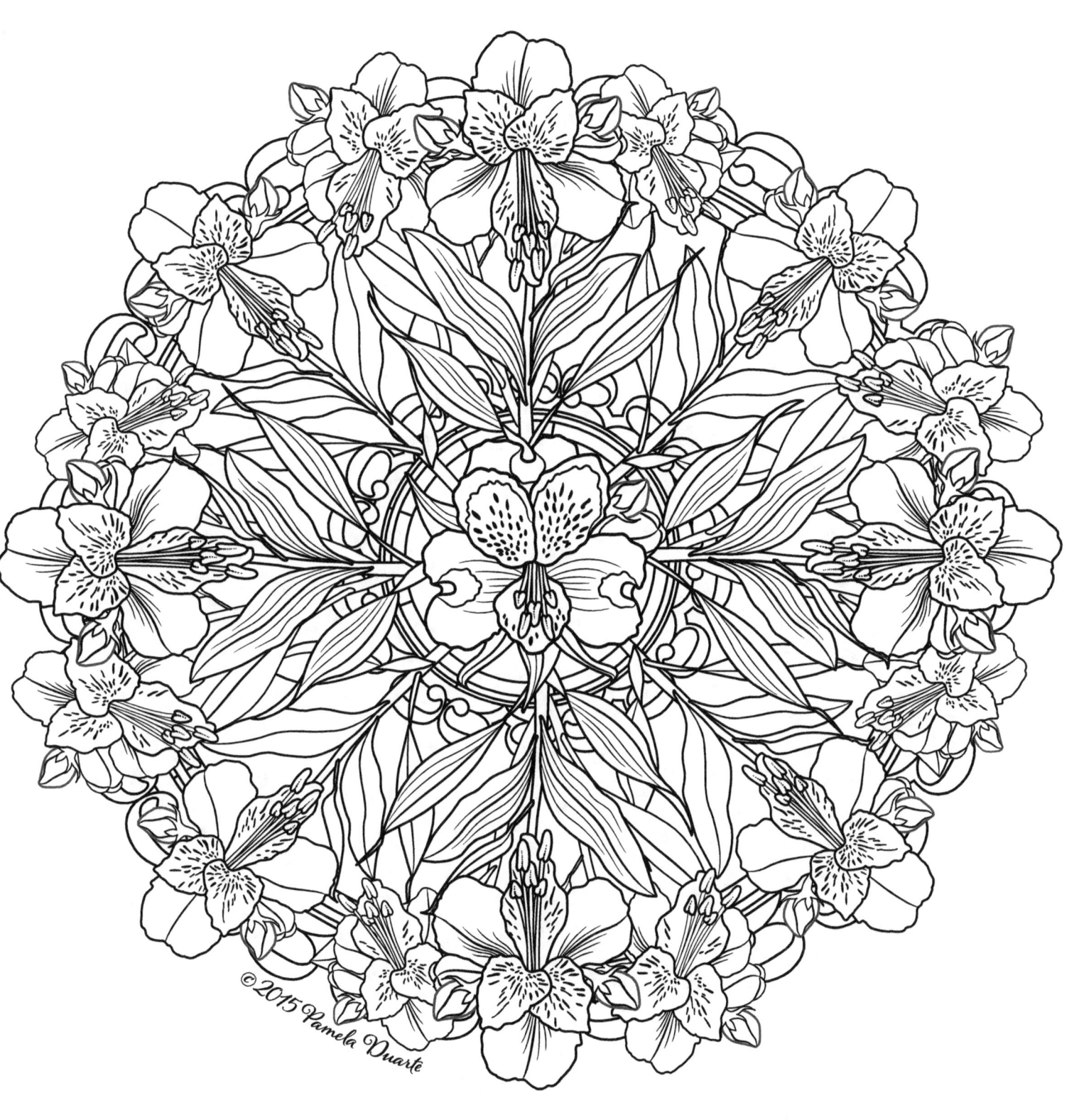

Peruvian Lily
Alstroemeria

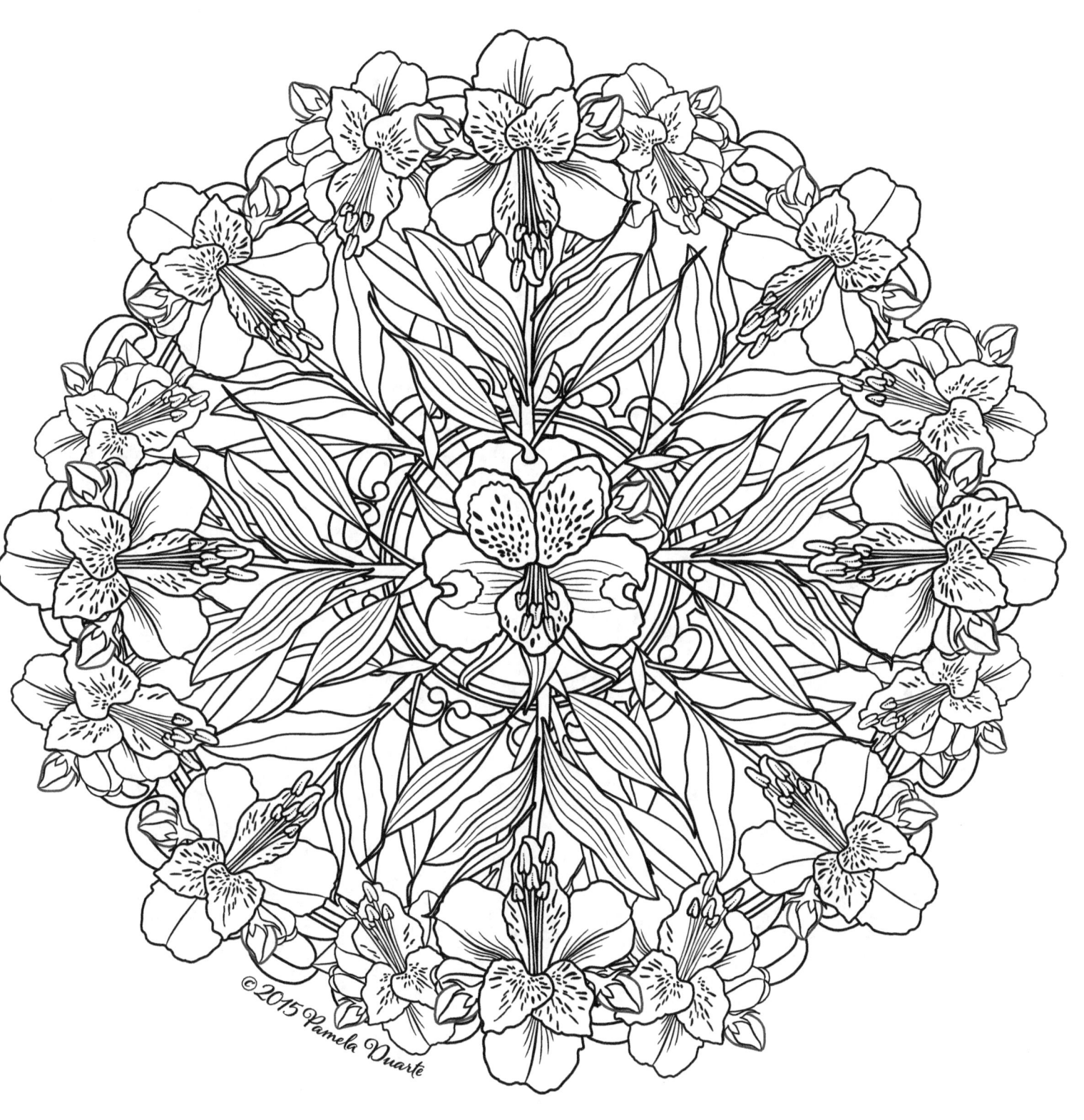

Peruvian Lily
Alstroemeria

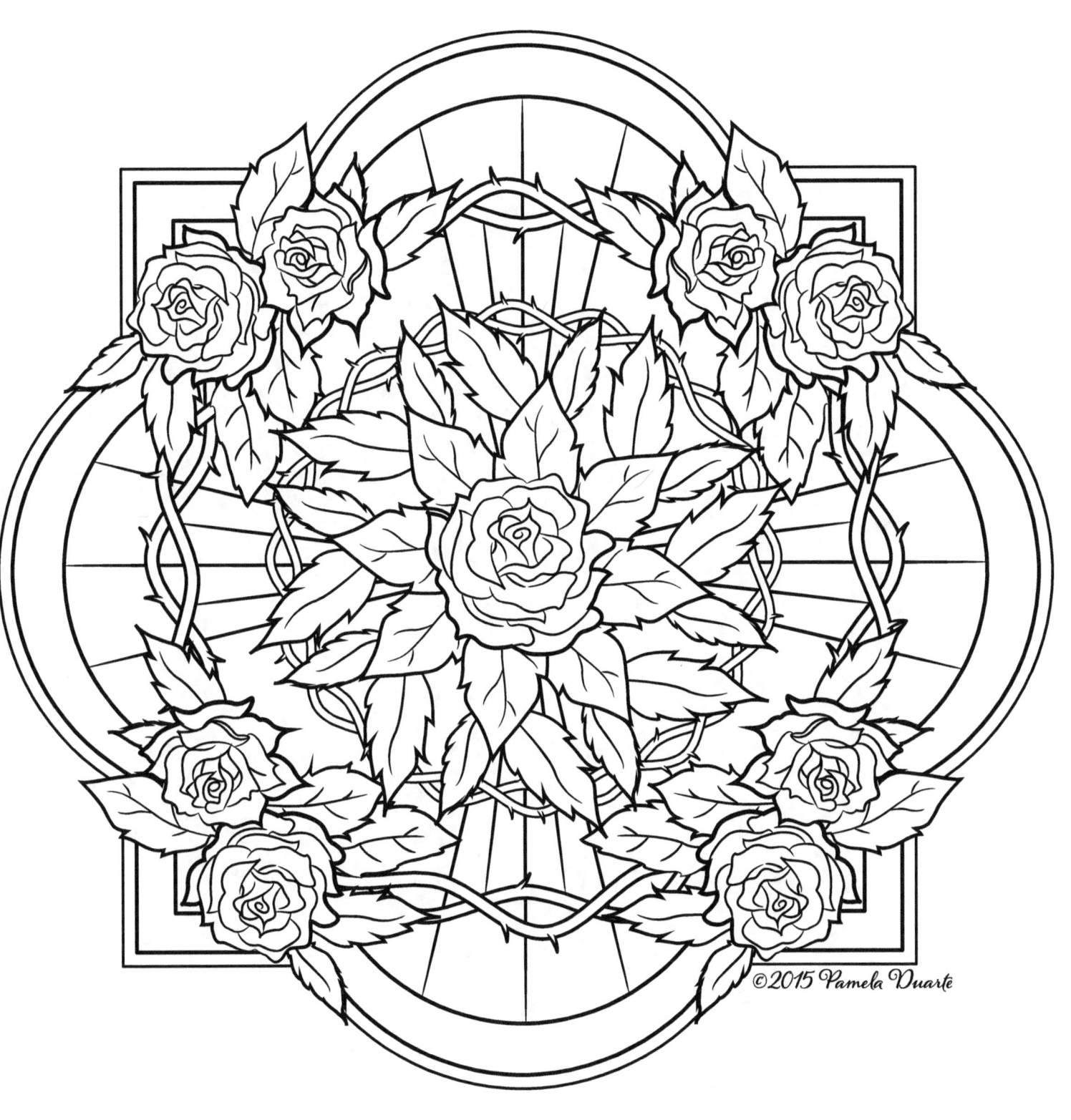

Rose
Rosaceae

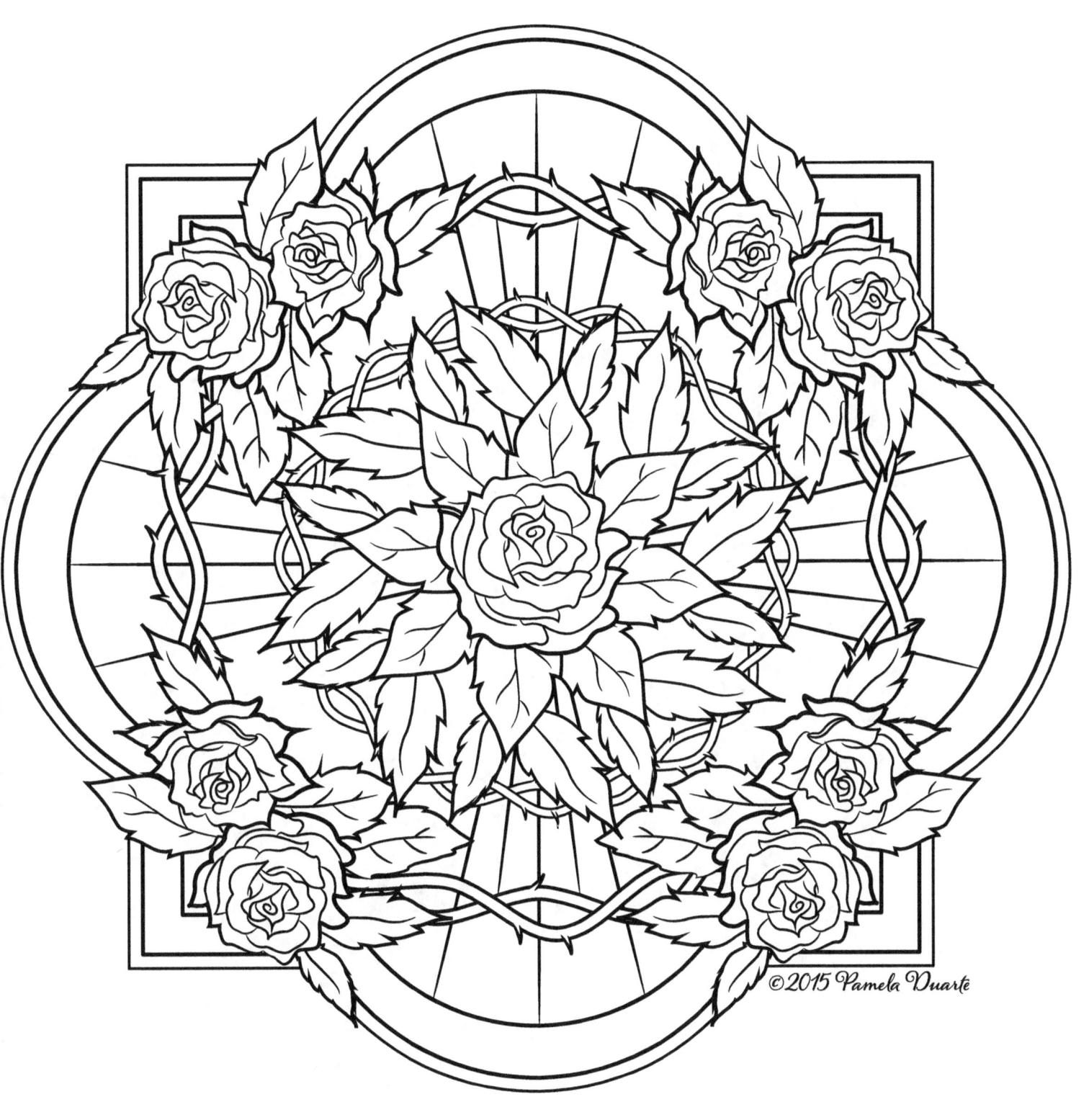

Rose
Rosaceae

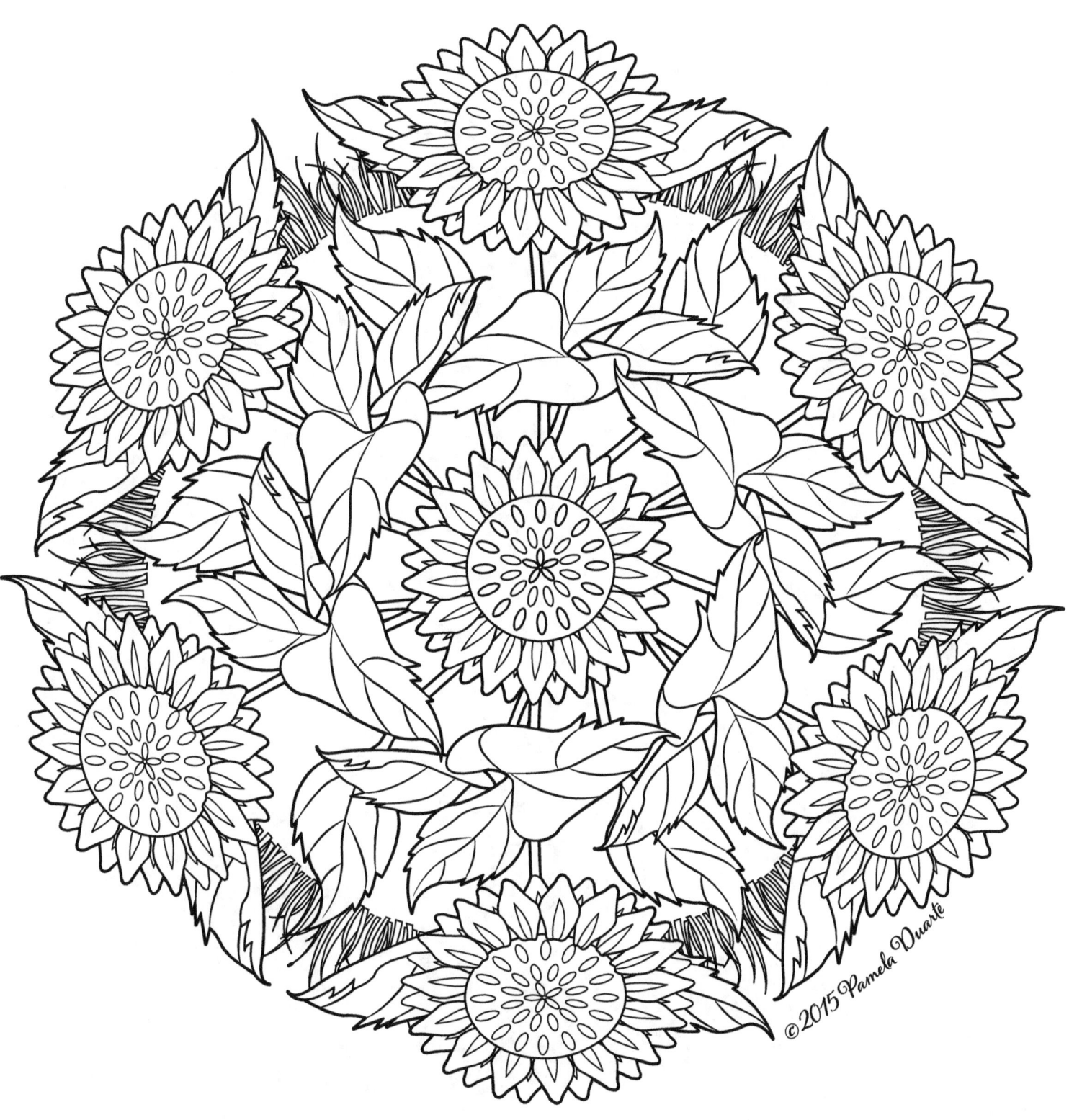

Sunflower
Helianthus

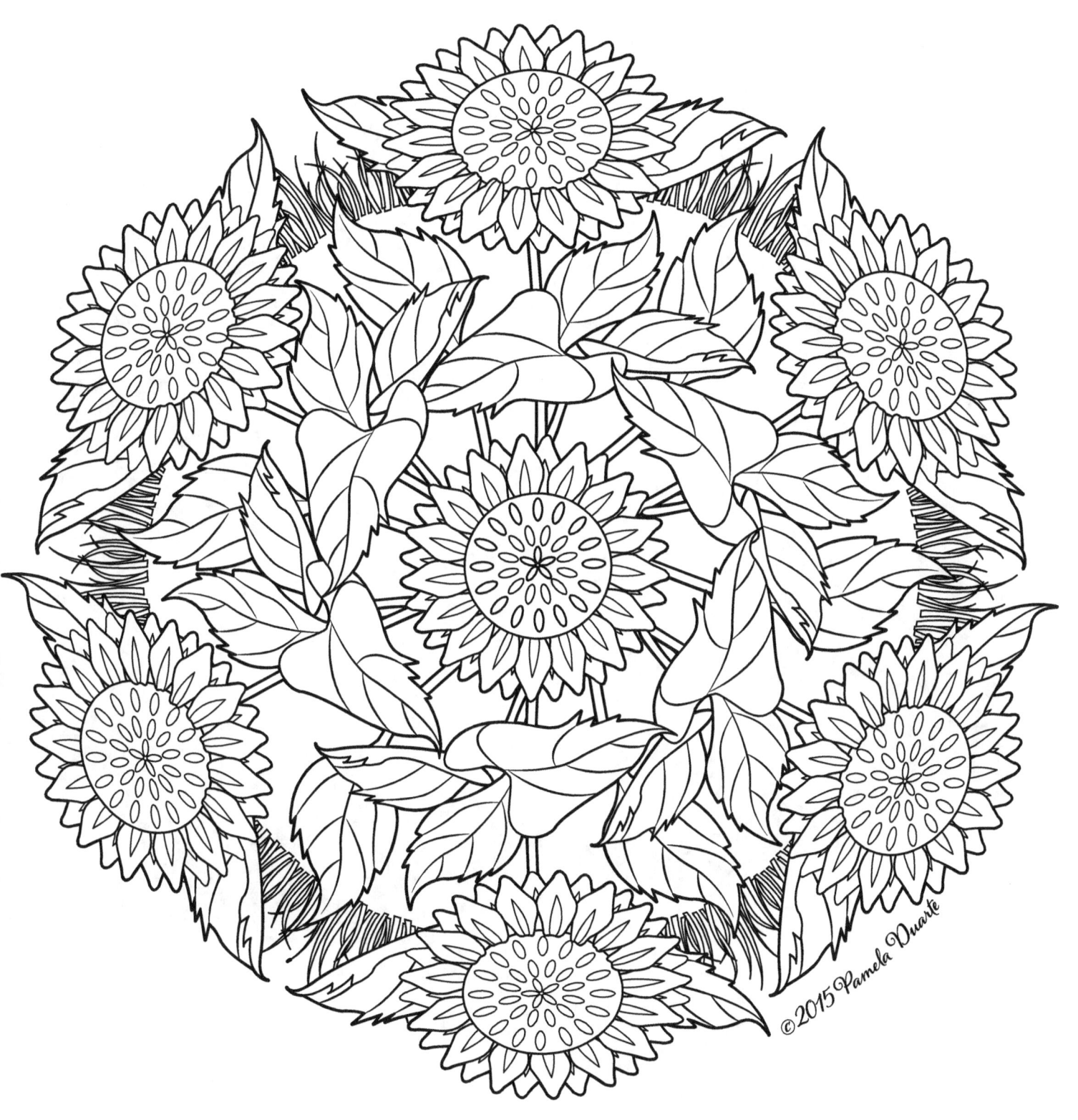

Sunflower
Helianthus

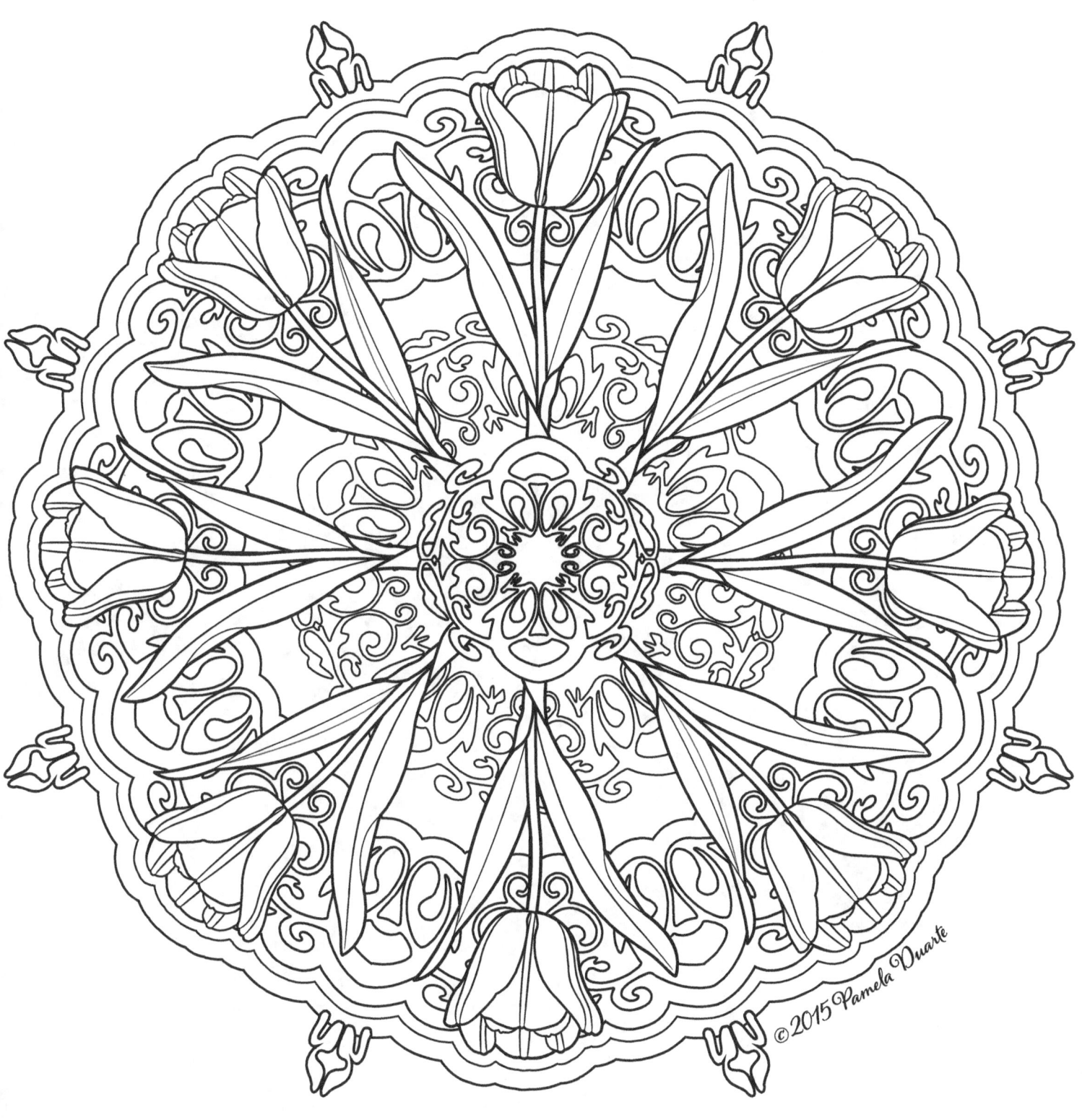

Tulip
Tulipa

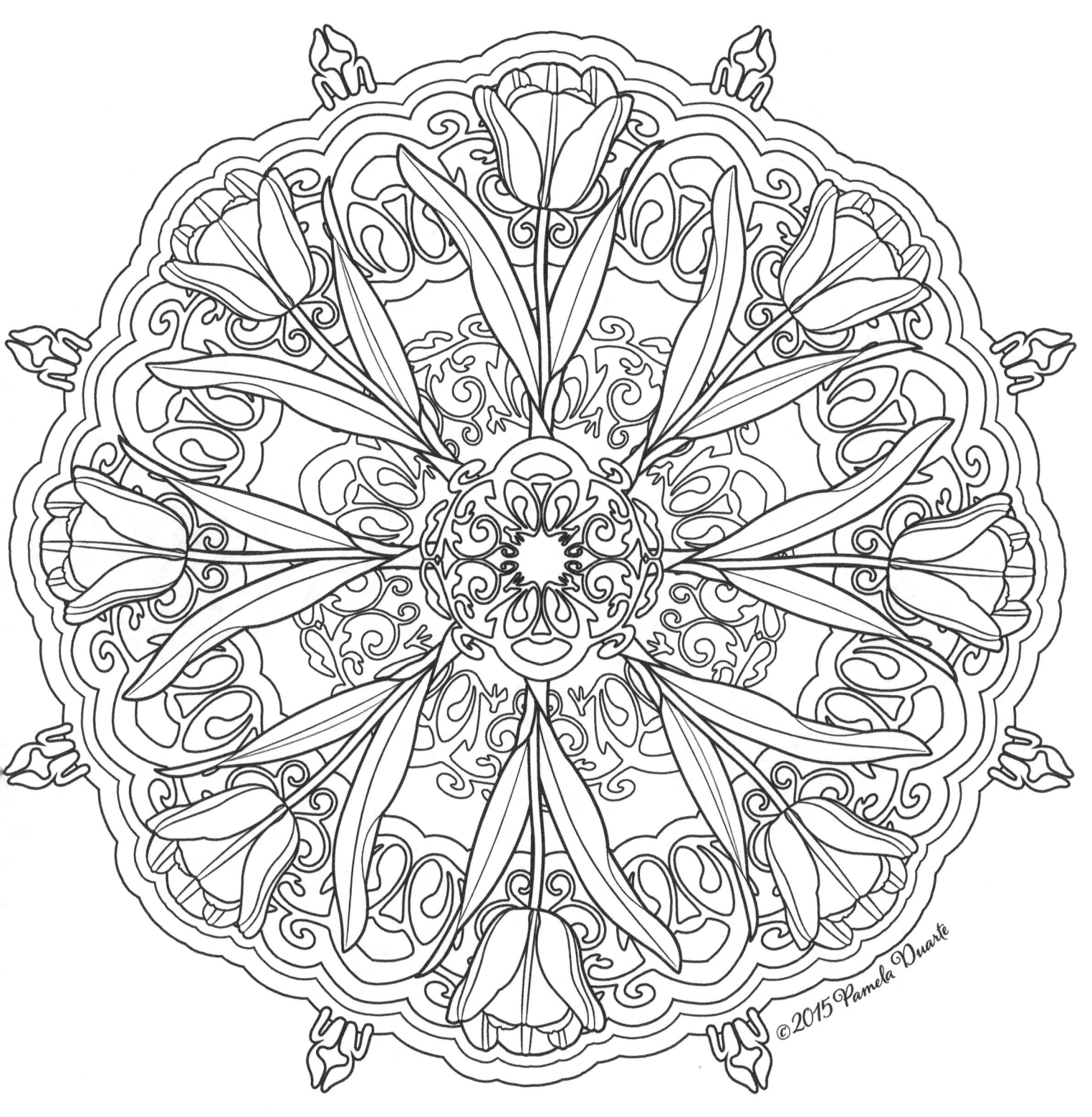

Tulip
Tulipa

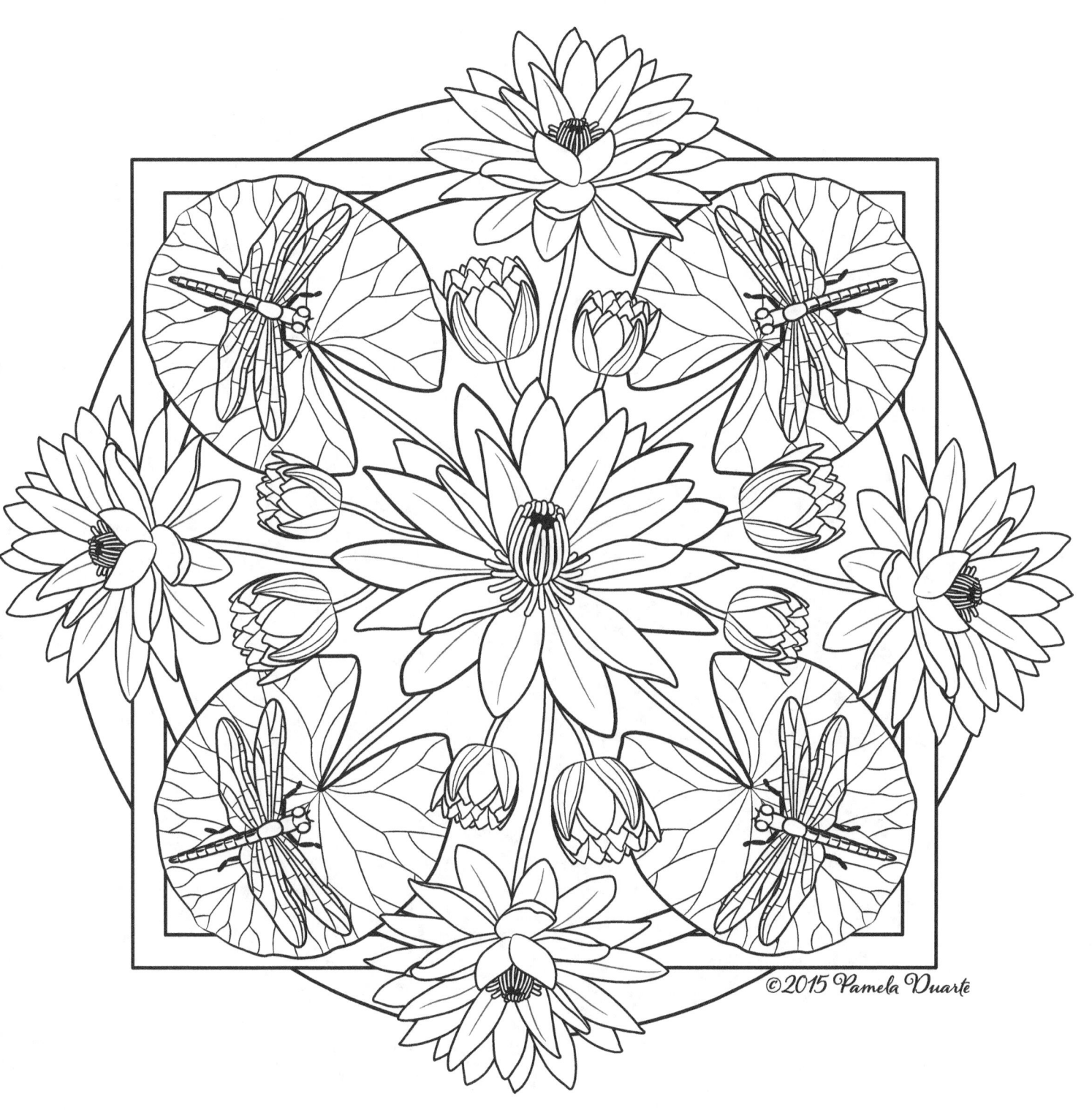

Waterlily
Nymphaea

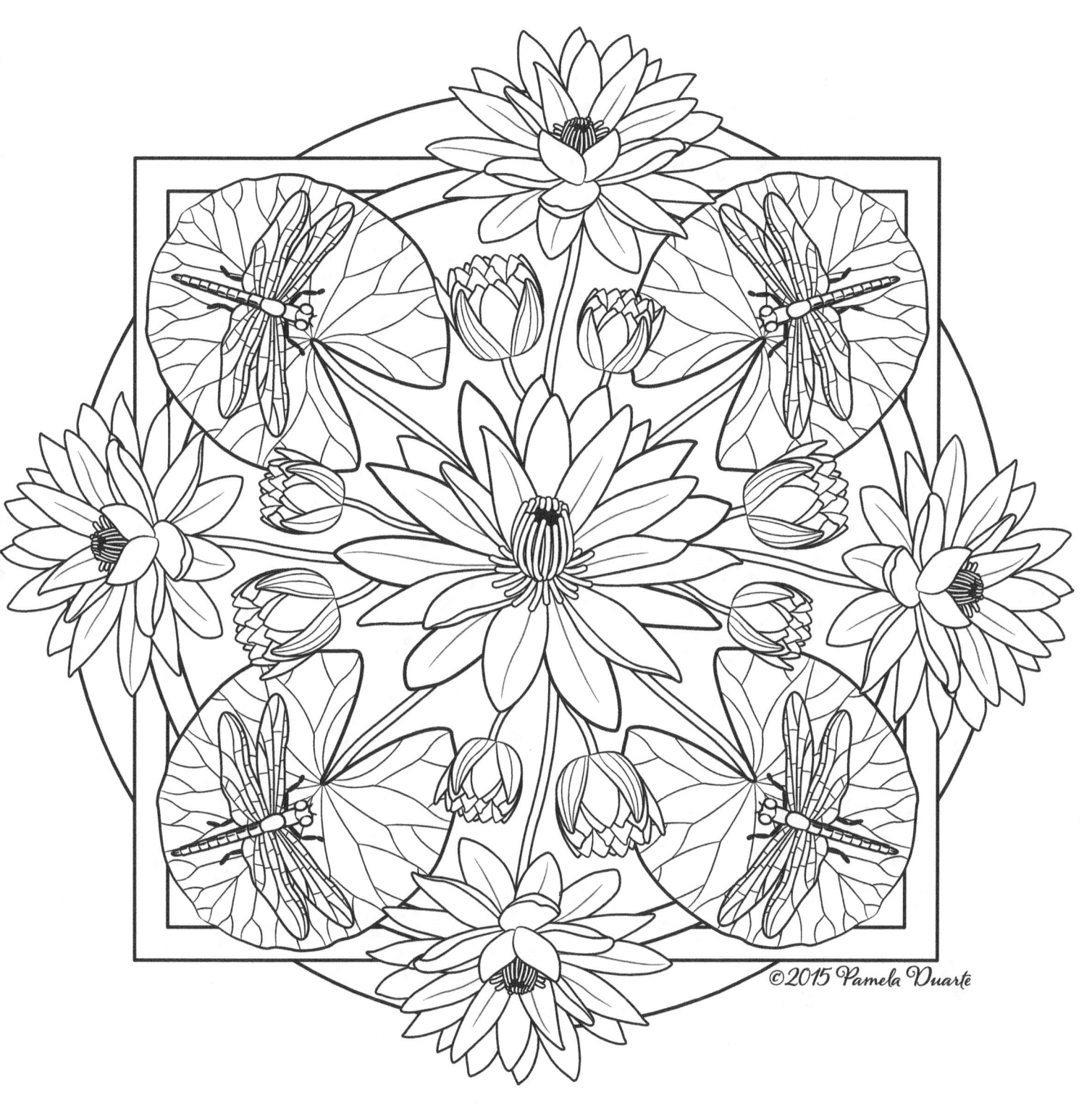

Waterlily
Nymphaea

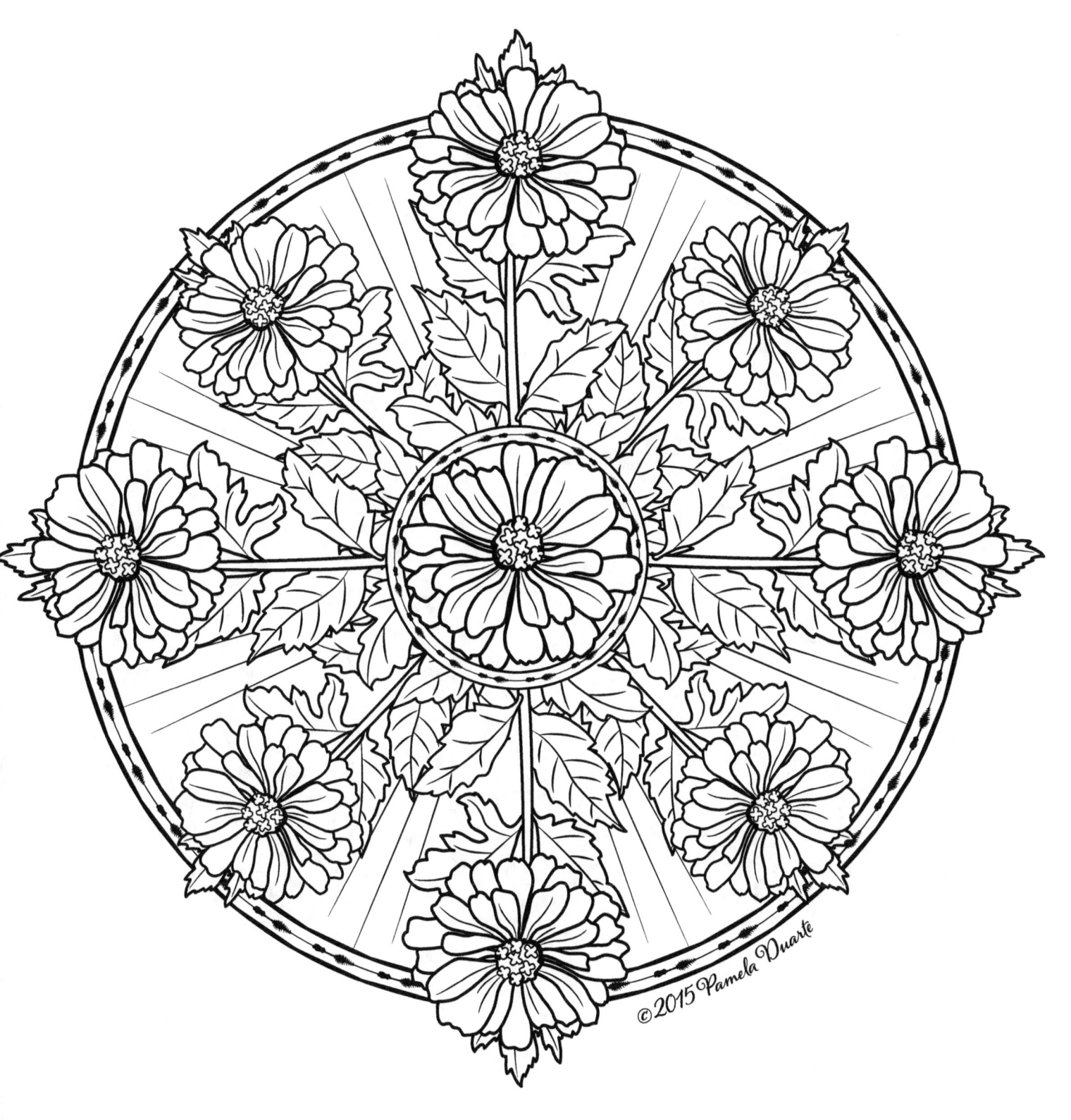

Zinnia
Zinnia Elegans

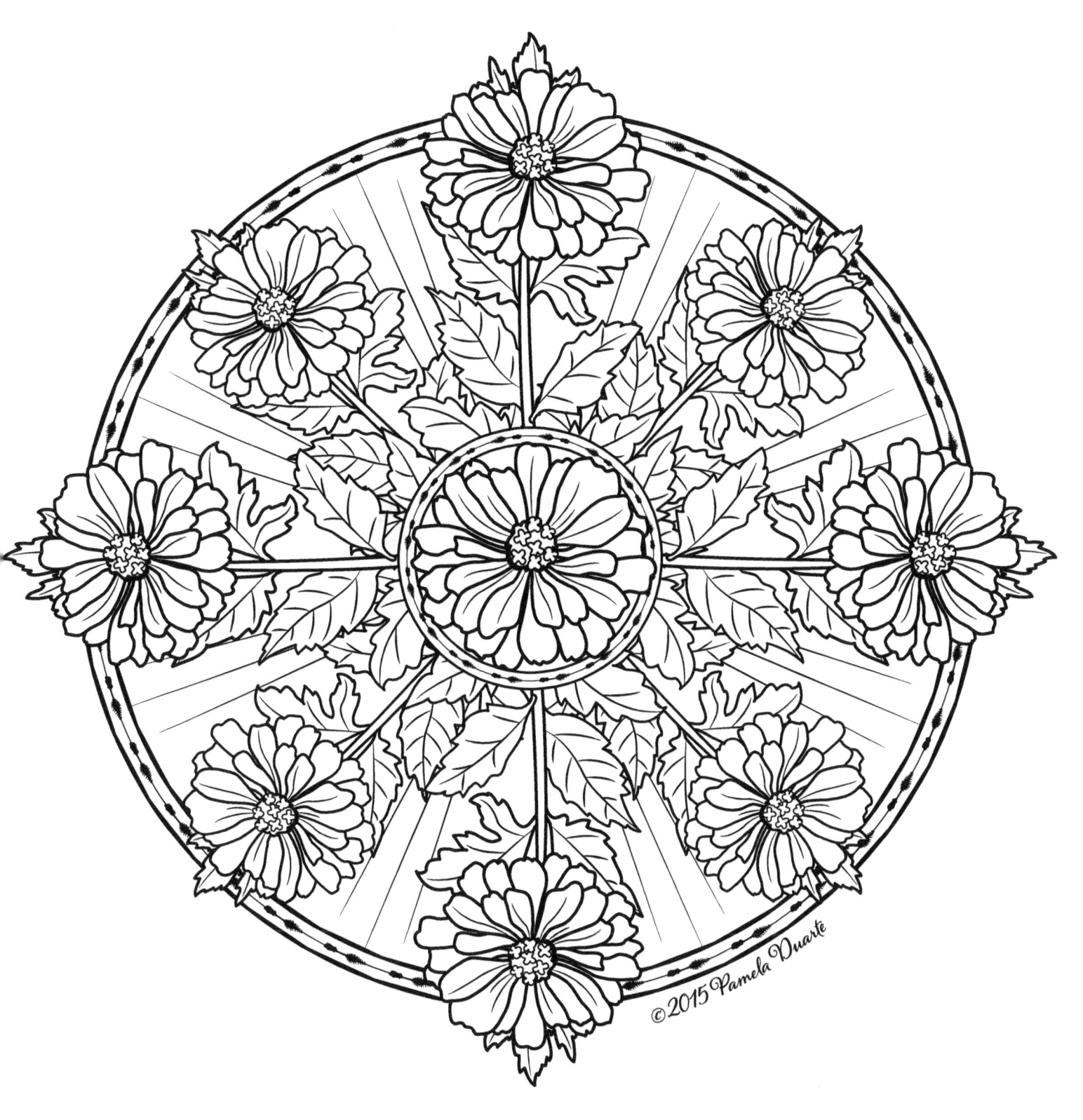

Zinnia
Zinnia Elegans

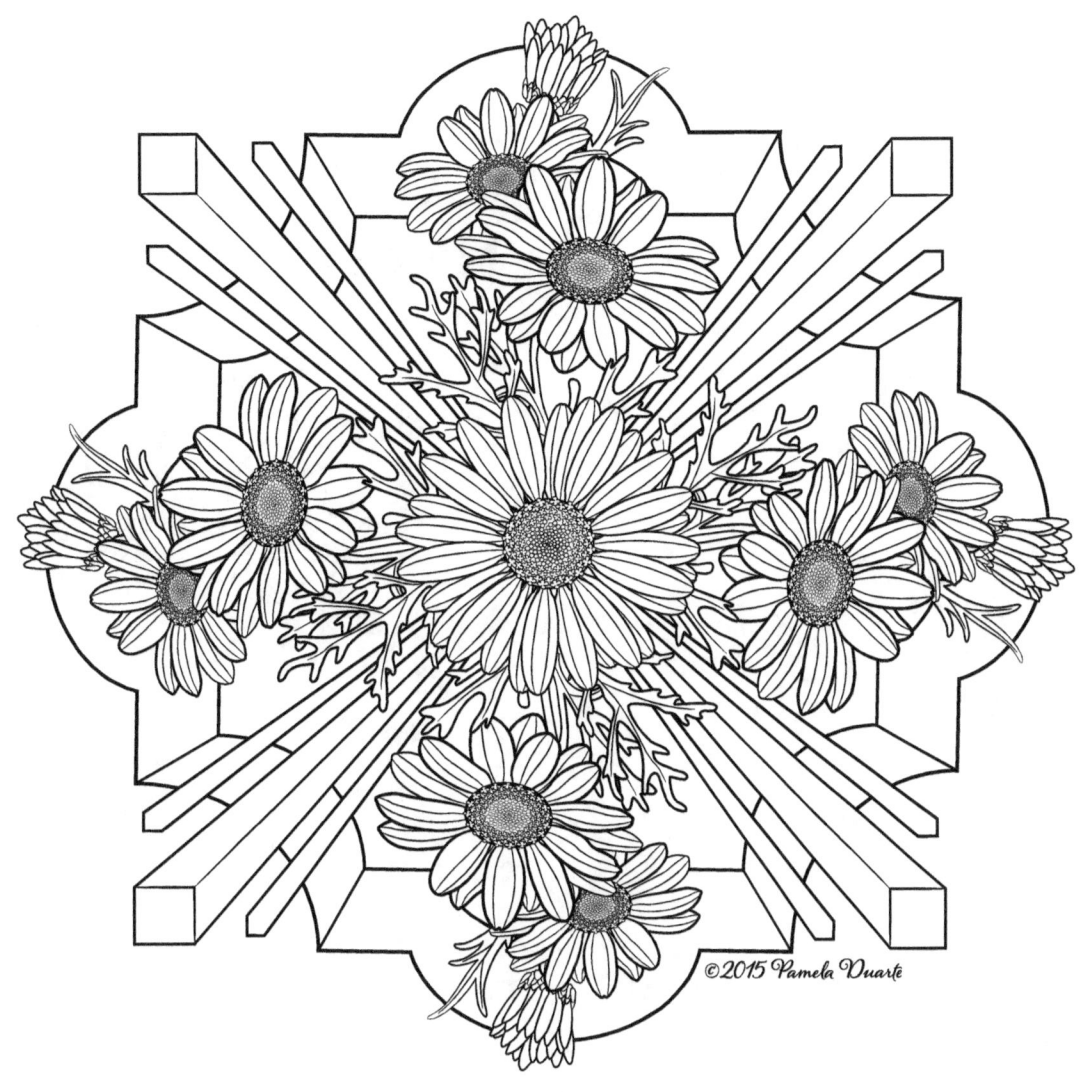

About The Artist

Pamela Duarte received a BFA from Art Center College of Design. After graduation she worked as a fashion illustrator and then segued into fashion dolls. She has worked on projects for many companies including Mattel Toys where she has illustrated Barbie and other products. She has also designed for toy companies in Hong Kong.

She loves to travel and has lived in Los Angeles, New York, and Bali. She currently lives in the peaceful Ojai Valley.

Other books by this Artist:
Botanical Flower Mandalas Coloring Book, Volume 2
Flower Patterns Coloring Books, Volume 1 & 2
Flowers & Fashion Coloring Book
Vivid Beauty Coloring Book

These illustrations are for personal use only.

www.ingramcontent.com/pod-product-compliance
Lightning Source LLC
Chambersburg PA
CBHW080920170526
45158CB00008B/2181